HOLINESS
AND THE
FEMININE
SPIRIT

HOLINESS
AND THE
FEMININE
SPIRIT

the art of
Janet McKenzie

EDITED BY SUSAN PERRY

ORBIS BOOKS

Maryknoll, New York 10545

Founded in 1970, Orbis Books endeavors to publish works that enlighten the mind, nourish the spirit, and challenge the conscience. The publishing arm of the Maryknoll Fathers and Brothers, Orbis seeks to explore the global dimensions of the Christian faith and mission, to invite dialogue with diverse cultures and religious traditions, and to serve the cause of reconciliation and peace. The books published reflect the views of their authors and do not represent the official position of the Maryknoll Society. To learn more about Maryknoll and Orbis Books, please visit our website at www.maryknollsociety.org.

Manufactured in Italy.

Library of Congress Cataloging-in-Publication Data
Holiness and the feminine spirit : the art of Janet McKenzie / Susan Perry, editor.
 p. cm.
 ISBN 978-1-57075-844-7 (cloth)
 1. McKenzie, Janet L. – Themes, motives. 2. Women in art. 3. Holiness. I. Perry, Susan.
ND237.M41178A4 2009
759.13 – dc22
 2009013184

For my son, Simeon,
whom I love beyond anything I can convey

Contents

Acknowledgments

I am deeply grateful to John and Marilyn Breyo for their enduring belief in my art. Their friendship reinvents the meaning of family. I want to express my gratitude to Patti and Richard Gilliam for their love and support, and for bringing the sanctity of New Mexico into my life and art. Gratitude to Barbara Marian, my strong sister of the heart, whose longing for empowering imagery of the feminine contributed to the creation of many works of art that would not otherwise exist. With deep appreciation to Sister Anita Baird, D.H.M., director of the Office for Racial Justice, Archdiocese of Chicago, who has repeatedly blessed me with her guidance. Profound gratitude goes to my Irish friend, Michael Farrell, writer, artist, and creator of the *National Catholic Reporter's* "Jesus 2000" competition, which altered my life. I am so grateful for his continued help and invariably brilliant perspectives regarding the ongoing and challenging journey of *Jesus of the People*.

Thanks to the National Endowment for the Arts, the Vermont Arts Council with Lyman Orton and Associates, the National League of American Pen Women, and the Ucross Foundation, who have all contributed to my evolution as an artist.

Thanks to the many models who lend their images to my work, in particular, Maria Hill Barnes, who, along with me, endured the slings and arrows as well as the celebration surrounding *Jesus of the People*. Maria and her children, Morrow, Apple Sophia, and Zephyr, appear in many of my paintings, and I am eternally grateful to them. Thank you as well to Dr. Janet Moses, Jessica DiMartino, Jennifer Theroux, Rui Li, Nuthel Britton, Doris Vittatoe, and Jose dos Anjos for their repeated inspiration.

Thank you to every writer in this book for their fearlessness in joining forces with my art.

Profound and enormous gratitude is expressed to editor Susan Perry, who is the real visionary behind this book.

And finally, I am indebted to every person who has ever stood before my art and been touched by it. What I strive to reflect in my art is that sacred and inherent place within that connects us all beyond race and gender where no judgment exists. Thank you.

Janet McKenzie
Island Pond, Vermont

Introduction

Susan Perry

Janet McKenzie's paintings take my breath away. I first glimpsed her art on the Internet more than ten years ago when I was looking for an image for the cover of a book by an African American writer. The multicultural image I found seemed perfect. Over the years Janet sent me postcards and an occasional e-mail to let me know of an upcoming exhibit. We met in person in October 2007, when she exhibited some of her paintings and gave a lecture at a nearby retreat center. Standing in the gallery surrounded by her art, I was transfixed. Some of the paintings were nearly as large as life. As I took in the colors and the forms, it was impossible to find words for my feelings.

After Janet's lecture, in which she described her approach to art, we had a chance to talk and to get a feeling for each other. Two or three months later she called to say that she was considering putting together a book of her art in response to several requests from people who had purchased or viewed her art. Could I recommend one or two appropriate publishers? As we were talking, it suddenly occurred to me that this was a project *I'd* like to work on, and I asked Janet if she would consider a small religious publisher such as Orbis. And this is how the book you are now holding came into being.

Janet sent me prints of many of her paintings, and when I spread them out on a large table I saw several possible themes. The one I chose is the life and message of Jesus shown through the women who gave him birth and carried his message to the world. I imagined a text that would focus on the art but also lift high the holiness of the women who were such a vital part of his life.

Nearly all of Janet's paintings are multicultural: Mary might appear as Asian, or Native American, or African. The same is true of Jesus or the Holy Family or Mary Magdalene. These images — unusual at times because they are not what we expect — force us to open our eyes, to look more carefully, to rethink what we

may have simply assumed. As I reflected on the women who carried the message of Jesus to the world, it seemed reasonable, then, to choose saints who also represent a variety of traditions. These include St. Monica, St. Josephine Bakhita, Blessed Kateri Tekakwitha, and Our Lady of Guadalupe.

And it seemed natural as well to select writers who come from a variety of ethnic groups and represent different faith traditions. So a writer may be Asian, Native American, or from the First Nations, Hispanic, African American, Caucasian, or Roman Catholic, Episcopalian, Lutheran, or Presbyterian. My "dream" list of women writers included many friends and acquaintances and some writers I knew only by reputation. Janet also made many suggestions, including two of her friends, the best-selling novelist Ann Patchett and writer China Galland.

As I studied the images, some author choices were obvious. Who could write on *The Visitation* but Joan Chittister, who works tirelessly to bring women together to support one another? And the sober and dark painting, *Jesus at Gethsemane?* Jesus awaits his death. Who knows this agonizing wait better than Helen Prejean, who accompanies those on death row? And for *Jesus of the People,* the winner of the competition sponsored by the National Catholic Reporter to identify an image of Jesus for the new millennium, I'd invite Elizabeth Johnson, the outstanding feminist theologian whose book *She Who Is* opened eyes around the world to new ways of understanding the Christian faith. The positive responses to the invitation to be part of this project overwhelmed me nearly as much as the beauty of Janet's paintings. I'll not forget Helen Prejean's enthusiastic "YES!!" scrawled on a piece of paper and thrust into my hands at a social justice meeting.

Each contributor received a color copy of the subject of their reflection and also a color copy of *Jesus of the People,* the painting that introduced the art of Janet McKenzie to a global audience. Since it was first unveiled on NBC's *Today Show* in 2000, *Jesus of the People* has elicited strong reactions — shouts of praise but also threats of death. Passion surrounds this work of art. One of our contributors felt a need to respond to *Jesus of the People* and wrote a second reflection. We include it as well. It is one of those blessings, rare and unexpected, that occasionally come our way and enrich our lives.

The contributors were encouraged to write in their choice of styles, so readers can expect to encounter reflections of many kinds, including poetry, stories of personal experiences, and narratives that tell the stories of saints such as Sr. Josephine

Bakhita. The all-encompassing theme is holiness, the holiness that lies within all women and men and the holiness that is the path and goal of our many faith traditions. Holiness enriches us and empowers us. The message of Mary and Jesus — that God's will be done and that God's reign enter into every human heart — was extended through the many disciples who followed, from Mary Magdalene and the saints to contemporary witnesses to God's love.

Women disciples and saints live today as well as in the past — and the women who write on the pages that follow certainly must be included in this group. It seemed fitting that the last two images in the book describe the possibilities of holiness in today's world. *The Keepers of Love* presents two African American women who in the 1990s began a difficult struggle to restore and gain access to Love Cemetery, a burial ground in Texas that dates back to the days of slavery. And the final image, Janet's *Homage to 9/11*, portrays the Twin Towers as two women (both with closed eyes, one of African appearance and the second an Asian woman wearing a shawl resembling an American flag) who lean toward each other in mutual support. Sally Goodrich's reflection tells the story of losing her son in the attack of 9/11 and turning in peace toward the people of Afghanistan to find healing.

A viewer once told Janet McKenzie that when she sees her paintings, they remind her to stand up straighter. Her art compassionately reflects that we are created equally and beautifully in God's likeness. May this book, through Janet McKenzie's art and the words of our writers, remind all of us of our closeness to God and of our inherent sanctity as beings living together on this Earth. May we all want to stand up just a bit straighter!

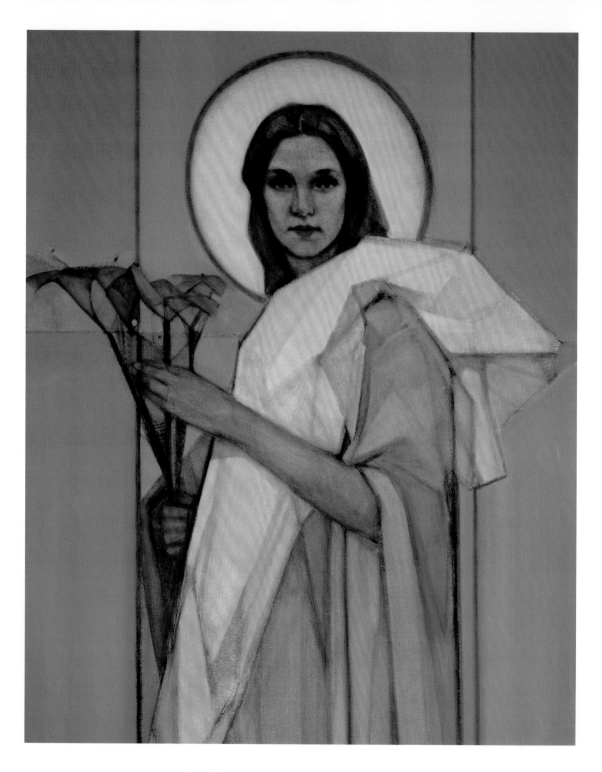

The Chosen One, oil on canvas (30 x 54 in)

Collection of Evangeline and James Brown, Oakland, California

The Chosen One

Janet McKenzie

 see the mother of God in women of all races and ages, although rarely do they know what I am seeing, or how inspirational I find them. Invariably there exists an untainted quality in each, and a prevailing hope, hope beyond reason. I saw Mary in the beautiful dark face of my friend as she poured her heart out, sharing that her race, her skin color, was something our country never lets her forget. Her eyes filled with tears of anger, and an aura of light seemed to surround her body as she spoke. My heart opened. At that moment I saw in her Mary, Mary, whose own eyes had to have overflowed with equally desperate tears for her inability to change the way things were.

I saw a chosen one in the face of a mother who brought her half-girl, half-woman child to meet me, out of sheer delight and the desire to have another mother see the beauty and uniqueness of her daughter. And, as a mother, I saw with my own eyes the miracle of my own child, and all I could say was, "Look! Look at him!" Certainly the Blessed Mother laughed with unbridled pleasure at the beauty of her perfect child.

My mother inspired *The Chosen One*. As Mary looks out of this canvas, imploring us to action, to belief, to courage, so my mother looked at me. Given the chance, she could have easily run Donald Trump's entire business empire single-handedly, yet she was born too soon. Instead she gave her life to her family, "doing the right thing," which is what she always encouraged me to do. The very last thing my mother said to me was that she loved me and that is my most beautiful memory of her. With no rush or panic, she looked up at me and said those words, and I echoed them back to her. I believe Mary, standing below that cross on Calvary, surely spoke the very same words to her child.

Several years ago I realized that I needed to paint specifically sacred art. My longing was undeniable, yet for some reason I could not give myself permission. I

1

reached out to a dear friend, the late Richard Fowler, a Catholic priest, to explain my feelings. He smiled at me. Putting his arm around my shoulder, he told me that I needed to trust what I was feeling and to begin. Somehow his words, and his kindness, opened a floodgate of emotion and creativity that simply has not stopped.

My sacred art speaks through the image of women, and often through Mary. She accepted God's invitation to do something beyond human understanding, and it is her courage that touches my heart and inspires me. She is a constant reminder of the power of maternal love. I see her in mothers and grandmothers who are raising children, and in mothers who have lost their children. I see her in women who fight for racial and financial equality at great peril to themselves and in women who stand up for change within government. I see her in women who work every day to make a difference, however small.

In some way, each of us is called to be a voice for good, and thus each of us is chosen.

The Annunciation

Mary E. Haddad

he poet and activist Muriel Rukeyser famously said, "The universe is made up of stories, not atoms." So it is that our story, understood as the greatest story ever told, is the story that keeps on being told. Every generation, every era, every community gets to tell its story anew, and often the most telling way the story is told is through art: pictures and paintings, icons and images. The cliché about a picture being worth a thousand words means that a picture is supposed to be able to stand on its own without the need for any words. Maybe so, except when the pictures are on the theme and variation of the Word made flesh.

Try as we might to *let all mortal flesh keep silence*, the beholder is drawn — as drawn as the artist is to draw — to say something about the story, particularly this story, the story announcing the birth of a word, a Word that will be made flesh. And there's the rub. The Word will become flesh, in nine months hence, if Mary says the word. Just as creation began with words, "let there be" light, so will the new creation begin with words, "let it be so." The annunciation must be followed by an assent. *Words, words, words.* Mary has to say something for the Word to become flesh. In the incarnation, the Divine will get messed up in the things of the world. Heaven will meet earth, and earth will meet heaven. They will touch. And yet in countless pictures and images, in countless artistic interpretations of the annunciation story, there is, quite literally, a disturbing distance in this meeting. Ultimately, words would not be enough; the divine and the human would get physical. God's love, coming into the world, needs more than words. God's love needs to be embodied.

I have a book with the one-word title *Annunciation*, which contains over a hundred images of this story, of the otherworldly angel Gabriel appearing to an

3

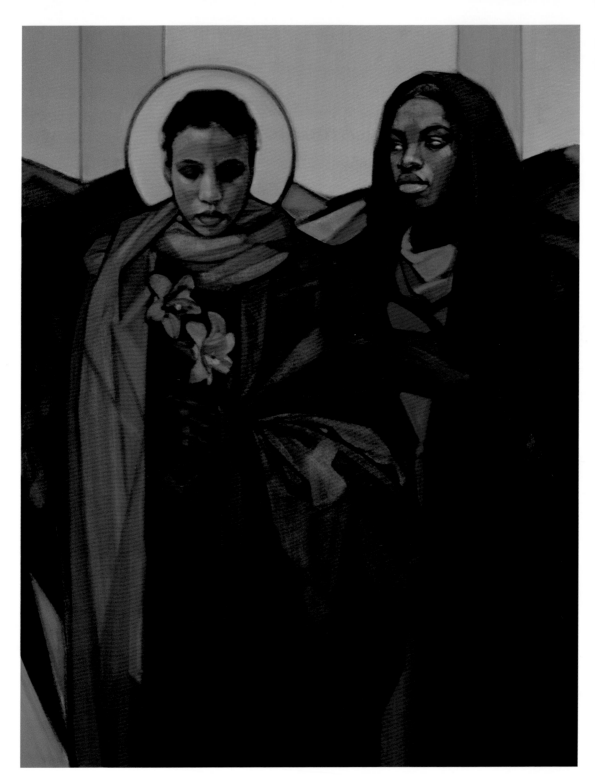

The Annunciation, oil on canvas (36 x 48 in)

unsuspecting Mary in this world. The book is a survey of the images used to depict this one-word story — annunciation — from a fifth-century mosaic to a late twentieth-century painting. Sometimes I flip through the pictures like a deck of cards and what I notice, almost without exception, is the considerable physical distance between Gabriel and Mary: distance between the divine and the human. Whether measured in inches or feet, there is a distance, an empty space between them; they never touch. In one amusing image from a fourteenth-century altar-piece, the distance is spelled out in a word balloon beamed like light from the lips of the angel Gabriel: *Ave gratis plena dominus tecum* (Greetings, favored one, the Lord is with you). Mary recoils and if she had a word balloon to go along with the expression on her face, it might say, "Get lost."

I find in this physical distance between the angel and the girl a paradoxical metaphor for the overarching role of women in the telling of our story about God coming near and dwelling among us. On the one hand, there is the unwitting importance and centrality of Mary, *theotokos,* the God-bearer, whose consent was a pretty big deal in making this story happen. On the other hand, there is the unconscionable marginalization of women by the institutional church, the oldest boys' club of them all. They put Mary on a pedestal and made her a perpetual virgin; in other words, perpetually untouchable, safely out of reach, and cut off from positions of power and leadership in the world that God so loves.

This disconnect in the story about Mary stands as a kind of primordial instance of approach-avoidance, a moving toward a relationship out of desire and then abandoning it out of fear. For me, the ongoing movement among ultraconservative Catholics to elevate the Blessed Virgin's status to co-redeemer with Jesus, while keeping women from significant leadership in the church, borders on the absurd. To this pseudo-veneration, one imagines Mary saying, "Don't adore me; ordain me." Mary made the story happen by saying yes and was subsequently silenced and written out of the story for the next two thousand years. Until now.

What jumped out at me when I first beheld Janet McKenzie's *Annunciation* was the profound intimacy of the meeting. The angel Gabriel's wings enclose and embrace Mary. There is no distance between them: they're touching! This is not just a meeting of the minds; it's a meeting of their whole selves, their souls, their bodies. What's more, heaven and earth stand side by side. Here, the mother of God is not a little lower than the angels or anyone else for that matter, and what good

news this is for all mothers, for all women, for the marginalized everywhere. There is no angel Gabriel flitting and darting about, beaming light on gilded images. Here, the heaven-sent angel is grounded squarely on earth; heaven and earth are both grounded in the love of God. And yet Mary stands on her own, poised to think deeply and independently about deep things and to make decisions on her own. Her downward gaze is a look inward. She has an inner life. She matters. She stands her ground, and yet she is not alone. *Hail, Mary, full of grace, the Lord is with you.* The angel Gabriel doesn't disappear into thin air; he is so grounded in her well-being that not even his eyes leave her side. His gaze is fixed on her.

Here, at the annunciation, the incarnation is but a glint in the eye of the Creator, but, oh, what a glimpse into another kind of story, a story for our time. As we near the end of the first decade in the second millennium, we have only now begun to live into the higher consciousness that was hinted at in the first-century annunciation when God spoke through an angel to an unwed girl from Galilee, for nothing is impossible with God. Sadly, the church has been so slow to let this story about the light of the world, borne by the unlikely Middle Eastern Mary, illuminate it enough to transcend categories of race, gender, and class. The stained-glass ceiling has been so slow to crack and really let the light in. Until now.

Janet McKenzie's 2000 *Jesus of the People,* with an African American as Jesus, stands as a prophetic rendering of the world to come, as nine years later, the United States marks the historic inauguration of an African American president with two Arab names, in a story that inaugurates a new era of hope in the nation and beyond. Hope is in the air in the world. The annunciation is a strange and outrageous story about hope for new possibilities. Whatever images we have of God, the annunciation to Mary inspires us to imagine God on the make, God eagerly and passionately desiring to come into our lives, to awaken us from our sleep so that we can embrace and embody the things of God. This is God on the make toward a new creation, a new world, never coercing us, but courting us to imagine a bolder vision of what it means to be alive and human and connected to each other.

By whatever means — we cannot know — Mary knew how to recognize an angel when she saw one. Maybe she'd seen one before. But something within her — call it faith, call it trust, call it risk, call it her ticket out of Galilee — something within her said, "Go for broke." In a world where young girls like her

had no say in anything, Mary now had all the say in the world. This is no small thing for someone who was more possession than person in her patriarchal world. Hope was in the air in her world. As mother of Jesus of the people, Mary is mother of all possibilities, poised to take her story on the road.

This twenty-first-century painting of the annunciation speaks to a story that has finally come of age, a story of a world that can no longer endure disconnection. The human family longs for connection, for embrace, for meaning. God made us that way and invites us to broker the distance between us with more than words — with embodied love and practices of compassion and justice.

As for Mary, all generations continue to call her blessed. As the nonperson for whom God did great things, she continues to say yes and stands as an icon for the downtrodden and the dispossessed everywhere. In countless nations and languages and races, the "woman of a thousand faces" comes to those, both men and women, who see her as one of them. The woman of a thousand faces has one for each of us. And behind each face that makes up the universe, a story is waiting to be told.

Holy Mother of the East

Joanna Chan

esolute and brave,
The bearing of a woman-child
Thrown since birth by life to an uncaring, indifferent world;
Guarded, with hand clutching tight
A shawl and cape of muted shades and thick yarns,
Woven stitch by stitch under dim and unforgiving lights,
In alternating shades by design,
Generous enough to envelop a new life;
Face, opened and shrouded,
Turned eastward, colored by heavenly lights,
Youthful and not yet wrinkled,
Already ravaged by the elements,
Heat and draft and rain and aridity,
That accompany her search for shelters that constantly lie beyond reach;
Gaze, straight and steadfast, unwavering before whatever the foe,
Coming from eyes half shut,
Eyes that are defensive, ancient and slow to trust,
Too knowing for the tender years,
With a look for having seen too much,
And with an unrelieved sadness
For failing to ward off constant want and deprivation for the loved One;
Dewy lips, tender and full,
Ready to surprise and generously unfold;
As one among the countless walking among us all, invisible, inconsequential,
She bravely plods on, from sunrise to sunrise,

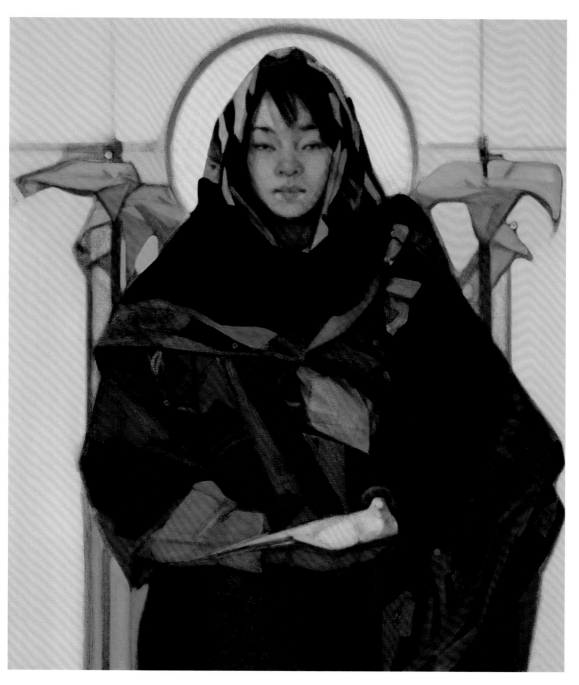

Holy Mother of the East, oil on canvas (30 x 30 in)
Collection of Cynthia Grenfell, Santa Fe, New Mexico

The preoccupation of the next mouthful never far from mind,
Yet standing tall and straight,
With face and hands gleamed by rays of the sun rising in the East,
Its orange and rose tints foreboding the threat of an approaching night.
Daring to bare her purity,
On her out-laid hand lies a gentle dove,
Homing on her upturned palm,
Not intending to take flight.
Crimson lilies stand guard from behind,
With stems unyielding as iron rods,
As determined as her "Let It Be Done."

Oh You Infinite One,
Who oversaw the coming into being of the universe,
How was Your time decided and Your abode chosen
In someone common yet extraordinary
As consummate as any parent,
As fierce as a lover,
As enduring as the sun?
What was it like to be clasped in that bosom,
Tender and sweet,
Filled with the promise of cherish,
Where joy and laughter were first felt,
Dispelling all fear and doubt and anxiety,
Of someone who lives sweat and tears and want and sorrow,
But whose all-consuming devotion and staunch determination
Could not shield You from an end too harrowing to name?
For she would let You go,
Surrendering You to betrayal and unfaithfulness and ignorance and bigotry,
Having passed on to You an unyielding faith,
Having imbued You with an abiding hope,
Now watched You stand defenseless and abandoned,
Wounded and vulnerable,
Wrongfully accused of a groundless transgression,

With no one stepping forth for a just word,
Rising beyond the constant visits of seduction,
Turning back on fear and doubt and hesitation,
In an act of total self-emptying,
Take on more than the sum of all common lots,
Step by agonizing step mount that barren hill,
With limbs nailed to the wood,
Arms outstretched gathering all in
So to render an erring world right,
In Your dying breath giving us a mother so dear,
She with the same arms waiting,
To grasp Your lifeless form in one final embrace,
In Your valiant "Let It Be Done."

And so our sorrows become Your sorrows;
Our pain becomes Your pain.
In ages kind and cruel,
In times prosperous and mean,
In war and poverty and destructions and abuse,
To a world of greed and prejudices and sloth and jealousy and hate,
You, O Infinite One, are born and born and born again.

Unworthy and negligible though I am,
Pray be born in me,
Gathered in that generous mantle as of old,
By her whom You gave to us as Mother in Your last gasps,
Held as dear by her with those ancient eyes,
Urged on to brave an uninviting world,
With the same unrelenting trust and stubborn hope,
Purposefully in search of the same humility,
Trembling with the same fear and doubt and hesitation,
With an unquenchable longing to bridge a fractured world,
To dare to self-empty with abandonment,
From deed to deed,
From moment to moment,
Attempting a timid and honest "Let It Be Done."

The Visitation

Joan Chittister

n Thanksgiving Day, 2008, a popular TV morning news show featured the story of the mother of a twenty-two-year-old soldier who had been killed in Iraq.[1] Part of a supply convoy servicing the perimeter of Baghdad, his Humvee had been hit by an explosion-rigged vehicle. Just days after his twenty-second birthday, the young man and two of his best friends were dead; a fourth, permanently brain damaged.

His mother, reading the diary returned in his army trunk, discovered the names of the friends who had been killed and wounded with him. Then she searched the United States until she found their mothers. They came from across the country to meet together now, these women. They hear one another's stories. They share a common bond.

In their mutual pain, these women have found both support and understanding. "There is no difference in our grief. It's absolutely painful," Doris said. "There is nothing in the world that is going to bring our boys back, but we have each other." For this small bit of shared humanity, for this cocoon of emotional safety, for this personal place of support in their grief and the hope of sustenance it brought for the future, they were thankful.

It is, I think, the same story Janet McKenzie is begging the world to see in her painting *The Visitation.*

The unique dimension of the story of this painting is that it's not unique at all. It's a universal one. But it has been invisible for far too long. Now, in our day, science has finally exposed and defined it.

"Artists treat facts as stimuli for imagination," Arthur Koestler wrote, "whereas scientists use imagination to coordinate facts." The real social impact comes when the two — art and science — merge into one awareness, into one great impulse toward a newer, more conscious way of being. When artists discover one of the

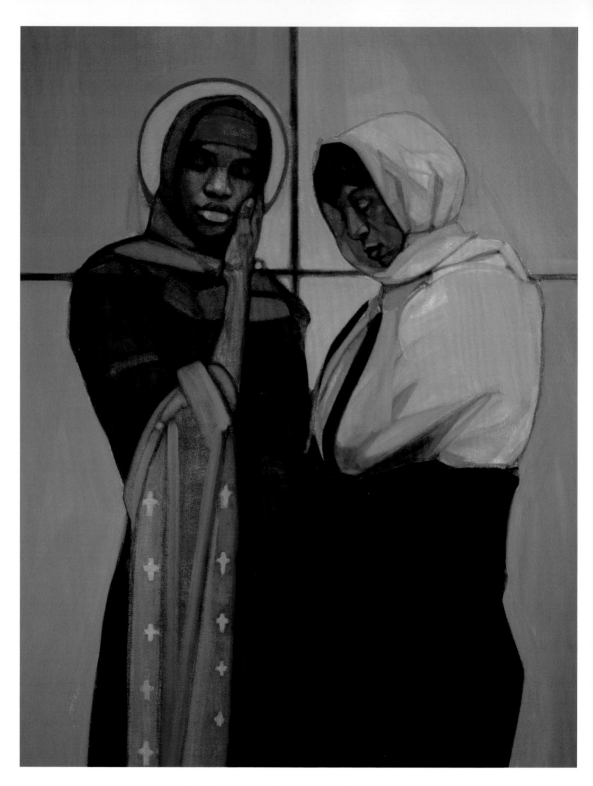

The Visitation, oil on canvas (34 x 48 in)

hidden determinants of life intuitively and scientists discover the origin of it experientially, the world of quarks and clones, parallel universes and cosmic expansion become a more readable story of the miracle of what it means to be alive. Of what it means, in the midst of interplanetary reality, to live our own small private lives.

When the artist and the scientist collaborate to discover another of the undercurrents of what it means to be human, life takes on a new level of spiritual evolution. Then we understand ourselves better. Then we understand life better. Then we understand better what it is we are meant to be. Then we recognize the ways of God better.

In our own time, it has happened. In fact, you see it before your very eyes — both in this painting of a time past and in the world around us now.

Janet McKenzie's *The Visitation* haunted me for days. There was simply lurking in it, behind the obvious, more, I thought, than the common awareness of the binding female power of pregnancy.

The fact that women share a common life-giving experience in the very chemistry of their bodies — whether they themselves ever experience pregnancy or not — is commonplace. The very word "woman" rings of "wombness" for many. But the haunting look on the faces of *The Visitation* say more. Much more.

The faces of Mary and Elizabeth, dark and somber, thoughtful and aware, in McKenzie's *Visitation* say something far beyond either the exultation of pregnancy or the creative power of it. This is not a picture about the delirium of motherhood. There is a storm stirring in the hearts of these women — deep and different than most at such a moment as this, something epochal and eruptive. The facts of this pregnancy are clearly different than the simple, natural dimensions of it.

This pregnancy, *The Visitation* implies, says that these two particular pregnancies are changing life in ways no pregnancy before them ever implied. These women, the picture is clear, are bound together in ways far beyond the physical. This pregnancy says that both the older woman — for whom pregnancy means a need for more vigorous energy than her years would commonly allow — and the younger woman — for whom a first pregnancy means new stature in the human community — are bound by something far more impacting than gestation.

The picture captures a moment in time — full of awareness, heavy with universal meaning. These two women know that what they are about to go through is not really two separate moments of life at all. The very act of pregnancy binds

them together, yes, but it binds them to all of life differently, as well. It has not only changed them, but it is about to change the history of the world. It is of them, of course, and it is far outside and beyond them at the same time.

This is life beyond their own small lives that they are facing now. This is life layers above the physical, oceans below the conscious.

And that's where science comes in.

For long now, women scholars have pointed out that at the moment of change, in the face of awesome, perhaps even terrifying awareness of her situation, Mary does not go to the men in her life for support. She does not go to her fiancé, Joseph, for understanding. She does not go to her father for protection. She does not go to the priests of the Temple for vindication. No, Mary goes to another woman. Mary, the pregnant but unwed woman, travels to the hill country to be with her old cousin Elizabeth, who is also pregnant, also dealing with overwhelming change and the isolating implications of it in her life.

None of it, the two women knew and the academic world realized over the centuries, made any human sense. After all, to be unmarried and pregnant in the Middle East of that time—in fact, in many parts of the Middle East even at this time—is dangerous space for a woman. She can be driven out of the family. She will certainly be forever disgraced. She can be stoned to death.

So, it seems sensible to wonder, why go to another woman, an old woman, who can herself do nothing to save her, who has no power to make the social situation better?

But to a woman it makes sense. Seeking the support of another woman in the midst of struggle has made emotional sense to women for centuries. And now it makes scientific sense, as well.

The science of women — women doing science — has finally opened new insights for all of us into what it means to be human. It gives the whole human community another way of reacting to life under pressure. It provides the world with a whole new way of looking at women and what women have to offer a world certain that its security lies in, as the psalmist says, "bows and shields, in carriages and horses" — in armies and nuclear weapons.

Now, thanks to a newly released and benchmark study, science and art come together in one great monumental moment that can make pain easier for all of us to bear.

According to principal investigator Shelley E. Taylor of a UCLA study, *Behavioral Responses to Stress,* "For decades, psychological research maintained that both men and women rely on fight or flight to cope with stress — meaning that when confronted by stress, individuals either react with aggressive behavior, such as verbal conflict and more drastic actions, or withdraw from the stressful situation."[2]

But, these researchers discovered, the participants in the five decades of research that consistently confirmed the "fight or flight theory" were primarily men. The UCLA study, using women rather than men for the first time in the history of the study of stress research, discovered that "fight or flight" is not the primary or normal response of women. Instead, science now understands, women under stress "tend and befriend." They gather with other women to construct other means of dealing with conflict and pressure rather than aggressive ones. Women, under stress, they found, take care of one another. They take care of children. They continue to concentrate on the functioning and development of the human community. They bring stability to situations of tumult and confusion.

The female hormone ocytocin, unlike the male hormone testosterone, the researchers tell us, steadies a person, brings order into bedlam, binds women together in support groups to keep the world operating in hard times. It is an indispensable element of the human condition; it is an essential component of social growth. It is plain proof, to both art and science, that to eliminate women from the great judgments and strategies of church and state is to rob the world of another way of responding to the kinds of stress that threaten its survival.

Now science knows what scripture and art, women and society, have known for eons. Mary and Elizabeth, Doris and the mothers of her son's now dead soldier friends — women everywhere — calm the chaos of the world. They show us all

another way to be in the midst of the daily maelstroms of life. They help us survive. They bind us together to carry each other, to carry the human community, to allow others to carry us when we cannot carry ourselves.

To look at McKenzie's *Visitation* is to look at an alternative world. It is to define the role of women in a new way. It gives new dignity and meaning to the friendship of women. It gives us all reason to believe that there can be a way through conflict other than force.

Notes

1. http://abcnews.go.com/GMA/story?id=6343621&page=1.
2. www.sciencedaily.com/releases/2000/05/000522082151.htm.

Magna Mater

Edwina Gateley

y name is Mother.
I am the Motherhood of God.
I stand poised on the birthing edge
and the universe is hushed,
held in awe
before the Great Event —
wrapped around
in rough cotton fabric
of indigo, turquoise, ebony
and crimson,
woven together into warm protection
by coarse brown hands
in a peasant village.
Ah, my little one,
you are clothed in beauty,
clad in brightness
to proclaim your coming.

My name is Mother,
I am Creator, Birther
of all things.
And in the great stillness
of my dignity,
I wrap you round, Beloved.
In my deep waters,
dark and gently stirring,

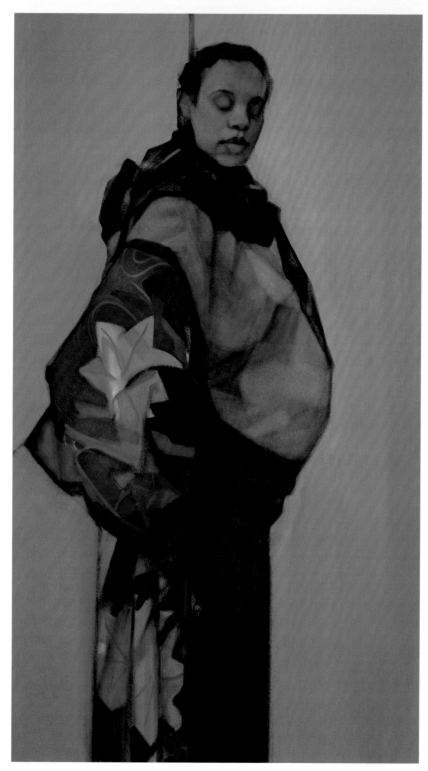

Magna Mater, oil on canvas (30 x 54 in)

I rock you into birth,
knowing that the music
of my lullaby soothes
your close awakening.

My name is Mother,
and you are mine,
intertwined with my being.
And as I gaze upon my belly —
swelling with your becoming —
I know I can never be complete
without You.
For my name is Mother
and in me
is all life-becoming.
I birth you, my child,
and in you is embraced
My divine love for all humanity —
black and white and brown,
male and female,
gay and straight.
All of these you are,
for all of these I am,
Creator of all.
I am Mother of all that lives,
of every color, shape, and sound,
all are inseparable from my dignity,
my Motherhood.

My name is Mother,
and I feed you, Beloved,
with my life-blood,
to nurture and sustain you,
to prepare you, dear One,
to carry my Presence

into the universe —
again and again and again.
For I am unceasing, and I birth you
from my endless longing.
And yet —
ah, so fiercely I would keep you
wrapped within me!
Utterly protected
forever.
But my name is Mother
And I must birth
and send you, Beloved,
into my universe,
my world,
my home.
I have set my hearth there —
in Iraq, Sudan, Ethiopia,
in Palestine, Guatemala, and China,
in England, Romania, and North America.
Wherever my people gather
there is my home,
and there are my people —
my beloved.
Ah — so proudly I birthed them!
With such longing
I sent them forth
to be lovers, friends,
holy saints, and mystics.
I showed them the way —
again and again and again,
as now I do with you, dear One,
to show them
the way again. . . .
To love, not kill,

to build up, not destroy,
to nurture, not plunder.
For my name is Mother
and I am Love.
Unceasingly will I create.
From my great fertility —
endlessly — will I pour forth
possibility.
And you, Beloved,
are my possibility,
Seed of my womb,
hope for the world.
You, dear One,
are my dream.
In you, Beloved,
resides all the potential
of the universe becoming.
For you are mine,
And my name is Mother.

In the fullness of time
you will slip, Beloved,
from the mystery
of my being and burst
with the freshness of new grace
into my cherished world.
Ah, then, my great swelling
will become a great emptiness
and, with trembling desire,
I shall watch over you.
every move,
every turn,
every step,
I will watch with pride,

for my name is Mother.
And you are mine.
And if, Beloved,
you should fall and cry,
I will weep with you
and comfort you.
And if, dear one,
fear surrounds you
and holds you tight,
I will whisper words of courage
to strengthen you.
For you are mine.
And my name is Mother.
Ah, listen to my heart beat,
Little One,
as I touch and feel the magic of yours
deep within me.
And, as you grow
in strength and stature,
I will follow the beat of your heart.
If it should falter,
so too, will mine,
for we are one, inseparable.
Listen to me, Little One,
listen, listen to my heart.

Curled within
your very being,
I hear your whisper, Mother.
I know your longing
and yearning,
your fierce love that
wraps me round
and feeds me.

But, in the darkness,
as you fill and swell me
with your life,
so must I leave
this warm, moist place
to carry that life
into your universe,
to be with your people, my people,
to tell them, Mother,
who they are,
to proclaim to them,
that they are precious
and beloved,
to show them, Mother,
how to love — like you.
And if, oh if,
they should reject and hate me,
then still will I love them fiercely
and even die for them.
For we are One,
And all are yours,
all are wrapped around —
as I am now in you —
eternally in your love.
For your name is Mother.
And we
are Yours.

Mary with the Midwives

Barbara Marian

We are all meant to be mothers of God. For God is always needing to be born.
— Meister Eckhart, thirteenth-century theologian and mystic

hen I was a child, Advent meant a calendar of dates to cross off as we waited for the delights of Christmas. I was in my early twenties before I discovered the gift of Advent itself. It was after the births of my daughter and son that I began to connect my experiences of pregnancy and giving birth with the biblical stories of the teenage Mary and her motherly cousin, Elizabeth. I imagined the two of them catching sight of each other and rushing to embrace, swollen belly to swollen belly. As my babies became toddlers and then preschoolers, the weeks before Christmas brought vivid images of the nativity: Mary on the donkey, with Joseph plodding along through the cold and darkness, on their way to Bethlehem. I could feel her aching back, her thousand-years' weariness and those shooting pains down the inside of the leg that signal the baby has dropped and labor will begin soon. How scary for this teenage mother-to-be to face the delivery of her firstborn baby alone. I could not imagine that.

Despite the silence of the Gospels about the presence of midwives and the assertions of later texts that they arrived after Jesus was born and then only to certify that Mary was still a virgin (some holding that Jesus was not born vaginally but came forth miraculously from Mary's side), in first-century Palestine midwives would have hurried to Mary to assist during her labor, ease her anxiety and pain, and minimize some of the risks all women face in delivering a baby.

Although women are equal to men in doing what is necessary to sustain and enhance life, you'd never guess this was true by reading the biblical accounts of Jesus' birth. Mary is the only woman present. Two thousand years of nativity art

26

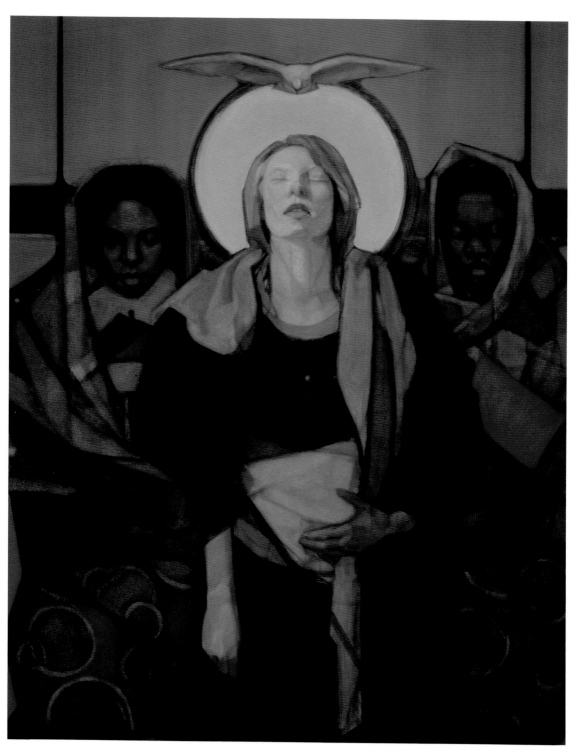

Mary with the Midwives, oil on canvas (42 x 54 in)

Collection of Barbara Marian, Harvard, Illinois

enshrined in the Vatican and other great halls of Christendom depict a cadre of important males — Joseph, Herod and his male advisors, kings traveling with male servants, and heavenly hosts more masculine than feminine singing to shepherds (all of whom have beards) — and one woman, Mary. She is portrayed as the only woman who had anything at all to do with the incarnation, the foundational story and first doctrine of the Christian faith.

Yet it is stories and visual images that shape our values, our assumptions, our identities and self-concept, and our roles and aspirations — indeed, every aspect of our world. When women do not appear in the stories handed down by a religious faith as tradition and dogma, women's legitimacy and authority are undermined and their very personhood devalued.

The way women are perceived has everything to do with limitations imposed on them and the atrocities they suffer just because they are women — from being often considered as second-class members in the church to being victims of rape as a weapon of war by the state. On the other hand, inclusive art that lifts up the presence, giftedness, and holiness of women has the power over time to transform minds, hearts and institutions. Once women are perceived as equal to men and as respected and valued as men, they will no longer be trivialized or brutalized.

These are the experiences and reflections I brought to Janet McKenzie when I asked her to paint Mary's midwives. Janet's passion for celebrating the sacred in women produced *Jesus of the People,* her transcendent portrayal of Christ for the new millennium, which I first saw in 2000 in the *National Catholic Reporter,* a Catholic weekly newspaper. The article led me to Janet's website, where I found other portraits of strong, beautiful, radiant, mature women, most of whom were women of color. Once I met Janet in person and exchanged phone calls and correspondence with her over several months I came to trust her completely with my understandings and vision.

She was the artist I had been searching for over the past twelve years, one who would honor my own passion for new images of women, art that proclaimed the incarnate Christ in women and their presence and agency in the story of salvation. A year earlier her vision of women as magi gave us *Epiphany,* a luminous and inclusive interpretation of the feminine faces of wisdom encircling the One Who Saves. Now women who work to bring new life to others would be affirmed and sanctified in Janet's powerful interpretation of *Mary with the Midwives.*

Although I had seen prints of *Epiphany* and *Mary with the Midwives* I did not see the paintings themselves till months after they were completed. Janet wanted me to see them for the first time in a setting that reverenced the vision and the work. She arranged for the unveiling at the Cathedral Church of St. Paul in Burlington, Vermont, a center for Episcopal worship and religious art and artists.

On a bright fall day in October 2003 my husband and I traveled from Illinois to meet Janet at the cathedral. She had placed the paintings at eye level in a quiet alcove in the church. As the three of us entered I remember being so excited I could barely breathe. I had waited years to see the faces of our foremothers and sisters in the stories I had treasured all my life. And there they were, Mary and the midwives, wrapped in vibrant blue with the three kneeling before a glowing red background. As I walked closer, they seemed to be moving forward to meet me. They seemed so real, so palpable that I could hear them breathing. Janet's cheeks were wet with tears and I was weeping too. My husband's "Oh-h-h" was the only sound we heard. Transfixed before the images, none of us spoke for quite some time. And then we embraced, murmuring words of wonder and gratitude. My only prayer that autumn day was for the grace to carry the images to every place we could possibly go and to share the message they proclaim.

As I write this it is mid-December, in the middle of Advent in 2008. Lingering on the evocative details of *Mary with the Midwives* opens the way to reflection and contemplation. Here — perhaps for the first time in art — is a depiction of Mary as her labor begins, held in the embrace of two midwives. Janet grounds and supports the three holy women against vertical and horizontal lines suggesting stained glass or, perhaps, a window, through which we see the red of the sun setting — marking the beginning of a new day as time is reckoned in the Bible.

The midwives are black, pointing us toward the archetype of the Black Madonna, locating the origin of this visual midrash in the womb of the Earth Mother, and embracing the blackness of the divine mystery. The water-bearing gourds on their garments, designed and woven by African women, symbolize both womb and birth waters, recalling the sea of creation, the source and cradle of all life. Mary's skin color is light — representing women from other parts of the world. She wears the black robe the artist uses in many of her paintings to symbolize the offering of a cloak of protection to all who behold her.

The women's eyes are closed in heightened awareness and communion with creative energy within. Supported by the midwives, Mary draws the strength and assurances she needs as she begins to experience the pain and the labor of giving birth. Lips parted, she is exhaling, surrendering her breath and being to the Divine at work and shining within her, as a white dove, the classic symbol of inspiration and new life, hovers above.

In the book of Exodus midwives play an essential role in the story of liberation, yet they are "conspicuous in their absence" in the infancy narratives of both Matthew and Luke. Matthew used the story of Moses as background and a parallel to his telling of the birth of Jesus. It is interesting to note that Matthew, who considered Jesus to be the second Moses, did not connect the heroic midwives of Moses' community, Shiphrah and Puah, who refused to follow Pharaoh's command to kill boy babies at birth, with midwives to assist Mary for the safe delivery of Jesus.

In Luke's narrative, Joseph travels with Mary to Bethlehem to the home of his family of origin to be enrolled in the census decreed by Caesar Augustus. The women of his family surely would have gathered around Mary and seen to her every need before, during, and after her baby was born. Yet neither Matthew nor Luke thought it necessary to mention the presence of midwives.

The infancy narrative in the Qur'an, however, goes into detail about Mary's experience laboring to give birth to Jesus in Surah Maryam 19:22–27 (Juz' 16):

So she conceived him, and she retired with him to a remote place.

And the pains of childbirth drove her to the trunk of a palm-tree: she cried (in her anguish): "Ah! would that I had died before this! Would that I had been a thing forgotten and out of sight."

But (a voice) cried to her from beneath the (palm-tree): "Do not grieve! for your Lord has provided a rivulet beneath you;

And shake toward yourself the trunk of the palm-tree: it will let fall fresh ripe dates upon you.

So eat and drink and cool (your) eye. And if you do see any man, say: "I have vowed a fast to (Allah) Most Gracious, and this day I will not enter into talk with any human being."

At length she brought the (babe) to her people, carrying him (in her arms). They said, "O Mary! truly an amazing thing you have brought!"

The footnotes in my edition of the Qur'an state:

#2476. She was but human, and suffered the pangs of an expectant mother, with no one to attend on her. The circumstances being peculiar, she had got far away from her people.

#2477. Unseen Providence had seen that she should not suffer from thirst or from hunger. The rivulet provided her with water also for ablutions.

#2478. Cool your eye: an idiom for "comfort yourself and be glad." The literal meaning should not, however, be lost sight of. She was to cool her eyes (perhaps full of tears) with the fresh water of the rivulet and take comfort that a remarkable babe had been born to her.

The story in the Qur'an is a startling revelation. According to this account, no one is around to help Mary as she labors to give birth to Jesus. No one that is but Allah Most Gracious. God is with Mary. God is Mary's companion and birth-coach, comforting her, advising her, and providing what she needs to give birth: water to drink and for washing and food to strengthen and sustain her through her labor. God is Mary's midwife!

There are some who might bristle to see two black women serving a woman who is "white." I invite them to look again — to see beyond stereotypes of race and class and to recognize these women as our foremothers, prophetic Christ figures who, from the beginning of humanity's sojourn, have said yes to the call to serve those in need, to free the enslaved, to seek justice for the oppressed, to protect women and children from religious and political power that seeks to destroy them. To see in these sacred midwives and pregnant Mary a bridge between the Hebrew and Christian testaments. To see a bridge between women of the first and the twenty-first centuries. To see women laboring together to do what is difficult, messy, risky, humbling, scary, and exhilarating in order to bring forth new life. Let each one of us women see ourselves in these images of the midwives and in Mary as we give our energy, our expertise, our creativity, our very breath, blood, sweat, and tears to give birth to the Divine. Then our work, like Mary's, will be full of grace.

The Holy Family

Wendy Beckett

ealistically, it is impossible to paint the Holy Family: we do not know what they looked like. Their contemporaries left us no record of their appearance, and the four great theologians who wrote the Gospels were completely uninterested in the personal details that we so long to know. Their minds were wholly set on what Jesus was, his significance. He was fully man but also fully God; he offered humanity the truth of his Father, and no externals could be allowed to clutter up the strong deep lines of this message.

Artists, though, are forced to imagine for us the appearance of Jesus, Mary, and Joseph, and over the centuries, they have done so with great enthusiasm. Yet when we look at these pictures, from the Middle Ages on, beautiful as they are, we may not realize their relative untruth. They all show us a fair-skinned Jesus with a fair-skinned mother. If St. Joseph is in the picture, he is hovering shyly in the background, usually aged, heavily bearded, and fair. These are European families, usually rather aristocratic of aspect (except for poor Joseph), whereas the true Holy Family were Jewish peasants. The jolt many will feel when they look at Janet McKenzie's painting forces us to recognize the vast stretches of time and culture that lie between us.

The people in McKenzie's *The Holy Family* are not Palestinian. She shows us a group of poor people who have the unmistakable features of the African or perhaps the Mexican or Peruvian. Jesus, Mary, and Joseph did not look like this. But this is a wonderful equivalence, forcing us to recognize both difference and similarity. The whole painting is a marvelous interplay of realism and symbolism. We are compelled to rethink and to look twice. All three have dark skins, a flat Negroid nose, dark, short curled hair (though Mary's is longer), and full lips.

It is as if the unknown reality of those first-century peasants has been transposed into another key, one to which we can genuinely respond. We are aware of their

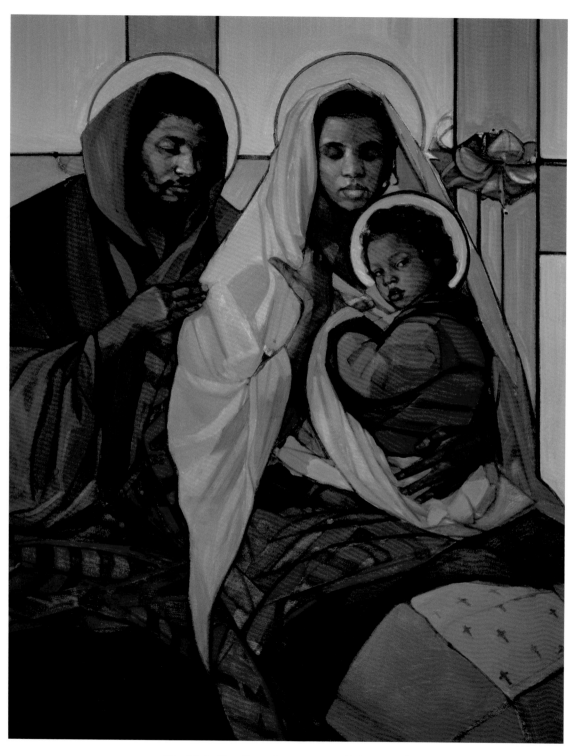

The Holy Family, oil on canvas (36 x 48 in)

Collection of Loyola School, New York

poverty. The couch on which Mary sits is patched, but its realism is set in an abstract context. Behind the family arises a geometrical patterning of lattice, palest pink in color and decorated with a flamboyant pink lily. The same touch of pink is visible behind Joseph's shoulder. Where are they? It would seem they are in some symbolic setting, where the lattice subtly suggests the cross, a theme picked up in the larger of the patches on Mary's couch. I am calling it "couch" because its true definition is deliberately obscure. Mary is seated aslant, which inevitably recalls the side-saddled journeys that we know the family took together. The family vehicle, the donkey, seems to be present, even if only in subliminal fashion.

It is with these journeys that the Holy Family is most associated. On the first, when they traveled to Bethlehem, Jesus was only present in his mother's womb as secure and warm as he appears to us in the painting. But he will sit on her lap, as here, when they flee Herod and they travel to Egypt, and when they return after Herod's death and live in Nazareth. Always Mary sits sidesaddle, holding the child to her heart, while Joseph either leads the donkey, or walks beside her, a protecting presence.

When next we see the Holy Family, they are in Jerusalem, and we are about to have a demonstration of the impossibility of parents and children ever fully understanding one another. We know the story, one with which many parents will empathize. When they leave Jerusalem, Joseph thinks the child is with Mary, Mary thinks he is with Joseph, and it is only when they gather around the fire in the evening that they realize to their horror that Jesus is missing. It takes them three days of frantic search before they find him in the Temple, talking about his heavenly Father. Even in this closest and most loving of relationships, the parents are wounded at what seems their child's thoughtlessness. (Thoughtlessness? Jesus, the Son of God? Yes, but a human Jesus who could make innocent mistakes.)

Mary reproaches him: "Did you not know your father and I have sought you sorrowing?" The twelve-year-old Jesus is astonished. How could they have sought him? Where could he have been except in the house of his heavenly Father?

No matter how deep the love, every human being is essentially a mystery. Here we see, for our comfort, Mary and Joseph accepting the disappointment that all parents must feel on realizing the unknowability of their child. Jesus, too, must experience the sadness of coming to terms with the truth of the human condition.

But if the Holy Family did not always understand each other, their mutual love and dependence was unshaken. McKenzie makes it beautifully clear that here is a family unit, three individuals bound together. We notice that both Mary and Joseph look not at us or at each other, but at Jesus. Highlighted by the glancing sunlight, Joseph's body language makes it unmistakably clear that he is devoted, body and soul, to the support of his beautiful wife, resolute to share with her the extraordinary responsibility of raising the child Jesus to manhood. This was most definitely not a one-parent family.

It took the church a long time to understand the significance of St. Joseph. In the very early church it was only Mary who was shown with Jesus, and she is seen very much as merely the means by which he comes to us. For centuries she was not seen as a person in her own right. To safeguard the doctrine of her virginity, St. Joseph was relegated even more to a background figure. Perhaps not until Murillo, in the seventeenth century, devoted believer that he was, do we have an artist who understood that a family needs a father, a role model, to use modern jargon, and St. Joseph was the man God had especially picked for this.

We can believe this of McKenzie's Joseph. We notice his sturdy shoulders, his lack of interest in anything but the mother and child. We see how gently and tenderly his broad workman's hand touches Mary's veil. (The veil itself, diaphanous and white, subtly recalls the bridal veil of a virgin.) Mary does not touch him — there is no physical contact — but there is emotional contact, beautifully understated. We see Joseph's fingers on the veil, but not his thumb. Bent toward him, we see Mary's thumb but not her fingers. It is as if together they form a hand.

If Mary and Joseph have eyes only for Jesus, Jesus has eyes for us. Like any child, who is completely secure in love, he looks out with an eager and innocent curiosity to an unknown world. Snuggled up in his warm jacket, he cannot imagine threats or danger. This, of course, is how it should be with every child, and a striking feature of this painting is how it appeals to the ordinary experience of a young family. The silent awe that Joseph feels is that of any young father faced with the wonder of raising a child. Mary's immense dignity, her majestic inwardness,

is surely that of a young mother holding her gift from God. The closeness and the sense of unexpressed devotion, which gives any family its stability, are here made visual. McKenzie wants us to see the Holy Family as writing large for us the holiness of the family, any family, our family.

The halos of the Holy Family, as McKenzie depicts them, are not the traditional gold, but rather a very pale purple that fits in unobtrusively with the subdued pinks and browns of the background. The dominant impression is of warmth, a deep and glowing inner radiance, at its brightest in the face of the small Jesus. Although McKenzie does not set herself to teach, still less to preach, this painting has a special relevance for our contemporary world. So many of our tragedies and discontents seem to stem from the decline of family life. All too often there is no father, or there is an absent father, and the child suffers from insecurity. Here we see the ideal: a man who loves his wife and her child and will devote himself to their protection; a woman who is secure in her husband's affection and in their joint responsibility for her baby, a baby who feels completely safe. The family is holy.

Madonna and Child — Boundless Love

Anita Price Baird

The Mighty One has done great things for me and holy is God's Name.

hen I first saw a photograph of Janet McKenzie's *Madonna and Child* in the fall 1999 issue of *Christianity and the Arts* I was so moved by the awesome beauty of the painting that I immediately entered into praise and thanksgiving. Clearly the salvation that had entered the world through Mary's "*fiat*" or "yes" is offered as pure gift to all of humanity. Five simple words, "Be it done unto me," changed the trajectory of the world.

In the Madonna's face I see great serenity and peace as she ponders the great mystery of God's love, which became flesh in her womb. The Promised One of Israel is her child. Because of her humility, trust, and total availability, God was able to do great things for her and through her. Mary treasured this unspeakable mystery in her heart, a heart so full of joy that she scarcely could hold it in.

Only two other persons would be able to understand her ecstasy, able to comprehend this greatest of all miracles: Mary's cousin Elizabeth and the baby who leapt in her womb upon hearing Mary's greeting to her cousin.

And how does this happen to me, that the mother of my Lord should come to me? For at the moment the sound of your greeting reached my ears, the infant in my womb leaped for joy. Blessed are you who believed that what was spoken to you by the Lord would be fulfilled. (Luke 1:43–45)

With that affirmation, Mary's heart exploded as she began to praise the goodness of her God.

My soul proclaims the greatness of the Lord;
my spirit rejoices in God my savior.

37

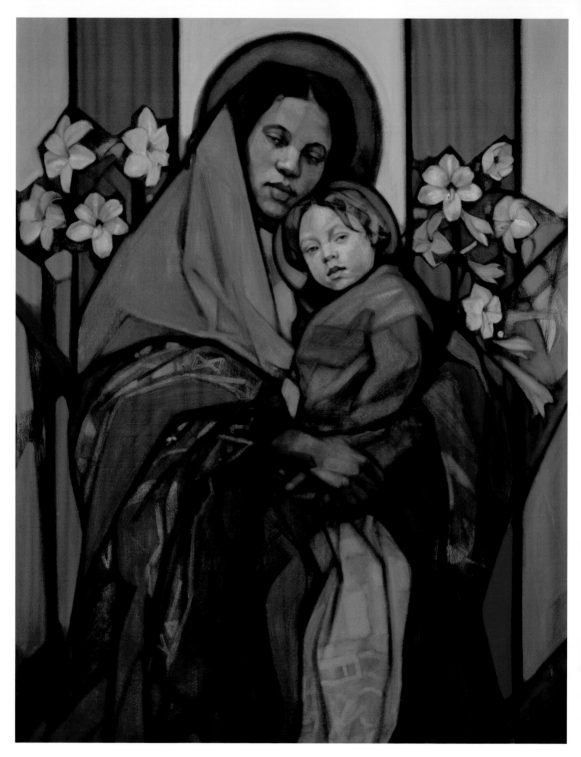

Madonna and Child — Boundless Love, oil on canvas (42 x 54 in)

Collection of Francis Cardinal George, O.M.I., Archbishop of Chicago

For he has looked upon his lowly handmaid;
behold, all generations will call me blessed.
The Mighty One has done great things for me,
and holy is his name.

When we look at this woman of color we see a woman who is one with the oppressed, the downtrodden, and the poor. She stands with those who are invisible, voiceless, and disenfranchised. She is one with the immigrant and the refugee. She celebrates God's redemption of the lowly and poor. Mary is a woman who believes in the power of God to right wrong. Her song is a hymn of revolutionary praise, for she knew what her God was doing and would do for those the world has written off.

This strong woman of unyielding faith is a woman with a prophetic vision of the truth and that very truth becomes flesh of her flesh, bone of her bone, and spirit of her spirit. As she gently caresses her son, holding him ever close to her adoring heart and wanting always to protect him from the harsh realities of life, she knows that this gift from God is not intended for her alone but for all who will receive her son into their hearts.

Her serene but downcast look suggests a foreboding reality that this gift offered in love will be despised and rejected by many. By saying yes, Mary was willing to risk all, to pay the ultimate price to do God's will. She chose to surrender completely to God's will for her life without counting the cost. Her reputation is in shambles. She is unmarried and pregnant. Her face shows that she has endured much suffering, yet she is filled with peace. While she did not know what the future would hold, she knew who held the future and she trusted God.

Rather than succumb to the burden of her yes, she rejoiced in prayer. She praised God and knew that he would never fail her. She stood on the promise that God who is ever faithful would do just what he said. It is her son in whom she believes and hopes and rejoices. It is her son who has made "her blessed among all women." And she, who is blessed among women, always leads us to her son. She holds the Promised One in her arms. She clings to him, knowing that her very heart would be pierced with sorrow for she is the Mater Dolorosa, the mother of sorrows.

As our gaze moves from the mother to the child, we find ourselves asking, Who is this child born of a virgin mother? Who is this child whose beauty is beyond

comprehension? Who is this child full of wisdom and grace? The answer is simple yet profound. He is Mary's baby boy. He is the one of whom the angel declared on that first Christmas morn,

> I proclaim to you good news of great joy that will be for all the people. For today in the city of David a savior has been born for you who is Christ the Lord.

He is the great I AM. He is the Alpha and the Omega. He is the Lord, Emmanuel. He is God with us. He is the Lily of the Valley. He is the Prince of Peace. He is Savior and Lord. He is God's perfect gift to an imperfect world.

Janet McKenzie captures the exquisite beauty of this sinless One, helpless in his mother's arms yet all-powerful, innocent yet all-knowing, fully divine yet fully human. He clings to his mother as he gazes compassionately upon the world. Does he understand his purpose? Does he know his destiny? Does he fully comprehend his Father's will?

In his face we see the nations of the world. His eyes gaze upon and invite us closer, drawing us nearer to him and his mother. When his purpose has been revealed, when his destiny is about to be fulfilled, his final act of selfless generosity is to give his mother to the world just as she gave him to the world. "Behold your mother." With those words she becomes our mother and we become her children.

This woman, "wrapped in silence," is the first among disciples, the first among believers, and the first one to proclaim the Good News. She offers the gift of hope to every generation, inviting us to believe in her son, to follow him, and to "do whatever he tells you."

In response we salute her and say, "Hail, Mary." We hail this woman above every woman who by her life honors all women. She is the first among all women. Through her veins flows the hope for the future, the hope for the world. In her we see the face of a God who, ever mindful of this humble servant, would extend his mercy to those who fear him, from generation unto generation.

For more than two thousand years, her children have sung her praises in every language and every tongue. Every day her name is invoked in the liturgy of the church. Cathedrals bear her name and pilgrims pay her homage. She is queen of heaven and earth. All generations call her blessed. Her children turn to her in their hour of need and pray,

Hail Mary, full of grace, the Lord is with you.
You gave to us your only child that we might live anew.
We bless you, blessed Mother, blessed be your children.

— Grayson Warren Brown, *The "Hail Mary"*
(Phoenix: © North American Liturgy Resources, 1979)

Madonna and Child — Boundless Love invites us to take refuge in the folds of her garment. We cling to her just as her baby did as we walk through this vale of tears. We pray to her and she intercedes for us. She wraps us in the mantle of her love and whispers words of comfort to us as she did to her infant son. She is our constant companion on this pilgrim journey. She is with us always, praying for us now and at the hour of our death.

We bless you blessed Mother and we are blessed to be your children, for your love is ever constant and knows no bounds. Holy Mary, Mother of God, we humbly implore you to intercede for us, and when this life is over and the hour of death draws near, come for us and show us the way to your Son. Amen

Mary and Jesus

Diana Butler Bass

 any icons of Jesus and Mary depict the Christmas scene. The newly birthed baby wrapped in a makeshift blanket, so very fragile, being tenderly cradled by his awe-filled mother. For those fortunate enough to have held an infant, such renderings draw the soul back to newborn intimacy, a fitting reminder of the deep human connection with God through Christ.

But the manger scene typically does not show us anything of the child Jesus. At the birth, we may feel protective wonder, a kind of spiritual tenderness, but we cannot really see Jesus. He is swaddled and cradled, his presence illuminated only by light. We see him only through the other actors, mother and father, animals and angels. The Christmas vision of the newborn Jesus is often one of hushed awe, of time paused to adore the mystery of holy infancy as Mary kneels by the improvised bed.

This icon, however, is not that of the infant Jesus. Here Jesus is a baby, well fed and sturdy, with wide and curious eyes and a full crop of hair. He appears to be eight months old or so, head straight and belly round. Under his mother's robes, his legs push and kick as Mary holds him firmly in place. If she was not clasping his hand, he might be stretching outward toward the unseen object that has captured his attention, reaching, as the artist may want to convey, in our direction. We see Jesus as a real baby, active and energetic.

This Jesus reminds me of a particular photograph of my daughter at the same age. She, too, was a robust baby. Although in the picture she was sitting in her crib, her legs were moving and she was reaching toward both the mobile above her bed and me. I remember those months well. When she was awake, she was never still, every limb was full of energy, her eyes sparkled, and she grabbed every toy. The photograph — though a static moment — communicates motion. At eight

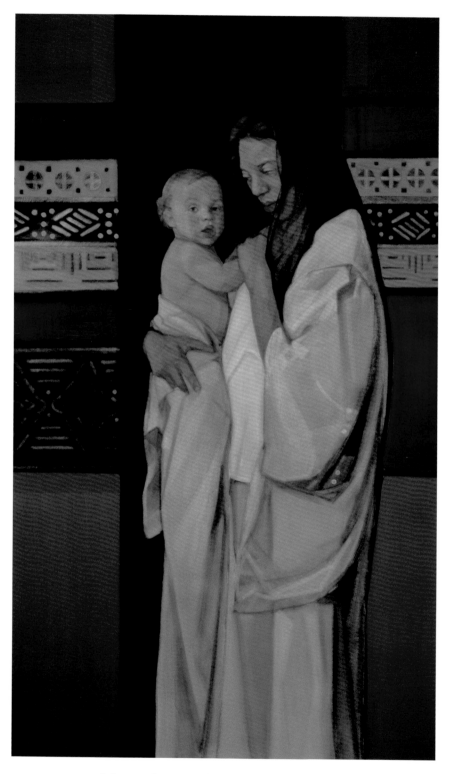

Mary and Jesus, oil on canvas (36 x 60 in)

months, she wanted to move, wanted to walk, wanted to touch the world. The only thing holding her back was confinement — either that of the crib or my firm grip.

Like my daughter in the photograph, Jesus looks as if he might jump. The blanket no longer swaddles; it is off. He wants to walk, to run, and to be free.

His mother no longer cradles him; she secures him. And her gaze has shifted from wonder to worry.

Early Christian literature is rife with speculation about Jesus' childhood. The traditional Gospels tell of his birth, the family's flight to Egypt and return, and an episode in the Temple at Jerusalem when Jesus was twelve. Besides these few stories, the accepted accounts are silent about Jesus growing up. The historical gap left open imaginative possibilities regarding the young Jesus. Writers of "infancy Gospels" spun tales of childhood miracles, such as making birds of clay come to life and striking blind the parents of a playmate who was a bully. Whatever the specific story, the childhood legends make the same point: that Jesus was special, different, and a miraculous little boy.

But Mary's look makes me think otherwise. How mundane it is for a baby to pull away from its mother's arms. How very normal for a mother to draw her child closer. Jesus appears as every other eight-month-old. No angel choirs, no holy light, no halo — just a crooked blanket that will not stay around his shoulders. He is reaching for the world; his mother holds on.

While we know that Jesus will grow up, reach out, and be rejected by the world, he does not know that. Nor does Mary. She is only acting the part of a mother. She does know that growing up is hard. She knows that her eight-month-old baby cannot walk however much he may want to. And she also knows that if the baby jumps from her arms, the child will be hurt. She knows about the perils of stairs and open fires, of wild animals and unkind neighbors. She knows how difficult it is to be Jewish under Roman occupation; she knows ethnic and religious oppression. She knows the shame of unwed pregnancy. She knows poverty. Her family does not know political, social, or economic freedom. Neither she nor the child she holds have any legal rights, they are both considered less than fully human, the property of another and are completely dependent on the whims of the state. They are peasants, just a step away from slavery.

Her world is plagued by sickness and disease. She knows all the daily dangers facing Jesus. She need not anticipate demonic tempters, untrustworthy friends, angry mobs, or Roman soldiers. Each day of motherhood brings enough worry for itself. She and her child live with the shadow of the cross. Jesus' actual death on a cross recedes from some in its horror when compared to the quotidian cross that mothers like Mary have borne for their children throughout human history. Being a parent is never easy — worry is mother's milk — but for the countless and nameless masses of our mothers, merely securing their babies' safety was paramount.

We may not often consider the quotidian cross. Yet it forms the background of Mary and Jesus' lives, as it does in this icon. Here, the cross is simple, fashioned from an African cloth, one used for dresses and turbans and skirts and shirts — a cross of everyday material. The cross is not something big, dramatic, or unusual beyond normal experience. Rather, the cross is just what it is — the fabric of daily life: all the things that deaden our souls and threaten our children; the things that keep us from our full humanity; the things that cause mothers to worry and to cling more tightly to their babies. The quotidian cross.

Although Jesus was born to the quotidian cross, he was born to defeat its fear, oppression, and enslavement. As preacher and teacher, he inverted the quotidian cross, always extolling the meek, the merciful, the peacemakers, and the poor. He pointed out how the everyday was holy. Jesus wore the regular fabric of humanity and by wearing it he redeemed it, coming to us as an infant to teach us the way to live and draw us into union with God. Through Jesus, God made the quotidian cross the path to life.

And Mary? Her worry was transformed into wonder once again. When she went to her son's tomb, a voice proclaimed, "Why do you look for the living among the dead? He is not here, but has risen." Mothers cannot hold on forever. The linen cloth that had wrapped his body lay empty; the promise of the baby Jesus was finally fulfilled.

Epiphany

Katharine Jefferts Schori

his image first struck me when I saw it as I looked for a Christmas card. I knew the artist as the same one who had painted a provocative image of Jesus several years earlier. Here was an expansive understanding of the depth of the meaning of Epiphany.

Epiphany is usually framed as "revelation to the nations," so that the good news of God in human flesh is available to all the peoples of this earth, not only the nation in which Jesus was born. The traditional way of understanding the wise ones who come to pay homage to the baby born in Bethlehem is that there must have been three, for three gifts are named, but also that they represented the known regions of the ancient world: Africa, Asia, and Europe. There is all sorts of legendary material about their names and status and life history — and like all good legend, the details vary from source to source.

What Janet McKenzie has done here is to invite us into yet another awareness of what it means that Jesus is born for the whole world. All of humanity is represented in these figures: yes, women! (by whom we all come into the world) — and also children and elders and those who were probably outside the normal experience of those kingly figures. This isn't just about the old joke that three wise women wouldn't have needed to ask directions and would have brought more useful gifts, like a casserole. This is about the ancient wisdom and ministry of women caring for other women as new life is brought into the world.

There is a yet deeper invitation in this image, one that builds on the ancient characterization of Wisdom as God's co-worker, present from the beginning as God's master crafter. It's an invitation to see Wisdom as a trinity, not unlike Rublev's — even with echoes of their staffs (of office?) in the background. The light of a star offers hope in the twilight, perhaps promise of a coming dawn, but certainly assurance of enduring God-with-us.

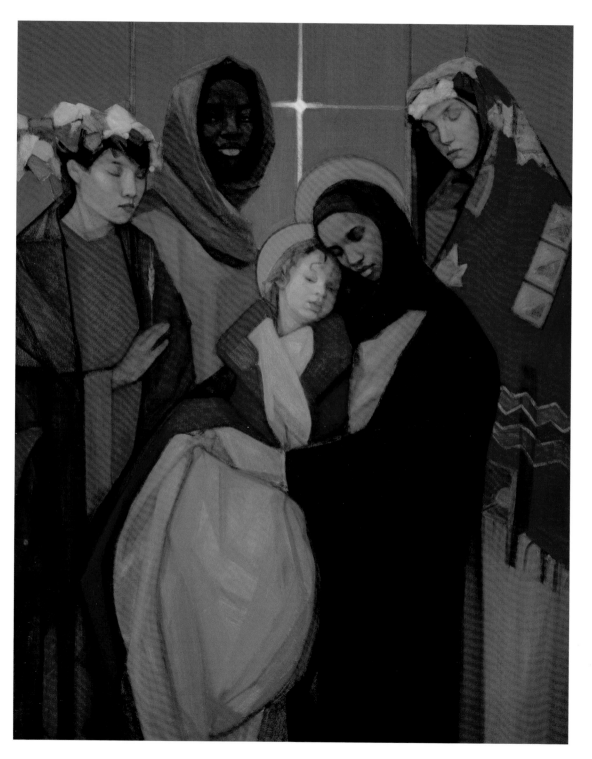

Epiphany, oil on canvas (42 x 54 in)

Collection of Barbara Marian, Harvard, Illinois

The figures themselves are restful, at peace, focused on the immensity of this moment, at peace on the journey inward. One figure gazes out at us, and invites us into the midst of this blessed community. Jesus himself seems to be peering our from under one eyelid. It's not quite clear whether he's sleeping or about to awaken. How often do we meet God like that? A tiny invitation, met and accepted, may awaken us into full awareness of the presence of God.

The three women bless in different and complementary ways — one extends a hand with a slim stem of wheat, one watches, and the third seems to be deep in contemplation. Mary herself has wrapped her young child in red garb, and seems to bear the burden of a growing youth lightly, for this is no longer a newborn.

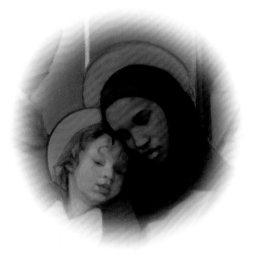

Where do we meet and acknowledge and bless God in our midst? That is the largest challenge Epiphany presents. It seems most often to be about finding God in the unexpected and surprising. When I sent cards of this image at Christmas a year or two ago, I got strong negative reactions from just a couple of people, who apparently *did* see something challenging. They were not able to see the invitation and experienced it as offensive. God born to a poor, unwed, and homeless mother in an occupied land offends many who seek a king who rules by force and images the power of the world. A God in human flesh who consorts with the unworthy and unclean does offend. Yet that very offense is an invitation to look more closely.

What is going on here? What is this strange thing, this burning bush that Moses investigates, or this teacher that Zacchaeus climbs a tree to hear?

I read recently about a rabbi who reached out to a Klansman who sent him offensive literature. The rabbi confronted the bigot with statements like, "There's a lot of love out there — and it sounds like you need some." And when he learned that the man used a wheelchair, he called up to say, "I hear you're disabled. Need a ride to the grocery store?" His striking words eventually elicited a response, "I want to leave what I'm doing, but I don't know how." The rabbi befriended him, eventually taking him into his own home in the last portion of his life.[1]

It's those powerful encounters, including the ones that are offensive enough to "catch" us, that in retrospect often show us God passing by. Those encounters may prompt the fear or awe of God in us, or we may respond with mere fear. The difference often has to do with our past experience — how we've practiced courage in other such encounters. Do we immediately run away in terror, or do we pause long enough to ask, Where is the blessing here? The women of this scene are clearly not consumed by fear or terror but are engaged in nurturing the surprising new life in their midst.

They offer a witness to sitting with pain, like the pangs of labor required to bring new life to birth, and discovering that all of one's being does not die in the process (though some portion may indeed need to die). They offer a witness to sitting with the joy and wonder of what this new life will be for the world — the whole world. What in us would need to be stilled in order to stand in witness with them?

What had been stilled in the women who stood at the foot of the cross? They did not run away in terror; they stayed to grieve with and for one they loved. Like women and men throughout the ages, they stood vigil with the dying. Like women at the birthing couch, they stand vigil as new life is brought into the light, even though it must pass through the gates of death. How do we stand vigil?

In Spanish, the verb used for giving birth means to bring into the light (*dar a luz*). How do we stand vigil with those who seek the light? Part of our labor as Christians is to stand in solidarity with those who are seeking rebirth into a world of justice — the quiet and unceasing service of caring for the wounded, feeding the starving, and cleaning up yet another mess from those who have acted too hastily or thoughtlessly. But part of our labor as people of faith is also to raise our

keening voices and cry out for justice, for that healed society where bellies are full and injuries healed. The ability to do that comes from the support of a community, of wise ones around us who remember that cries in the wilderness will be heard, and that there is a Hearer who cares.

This image gives us evidence of Wisdom still at work, at God's side, creating a world of which humanity has dreamed from its earliest remembrance. The hopes of the world are gathered in this young one, who is being grounded and surrounded and nourished by Wisdom. The world still waits for the fullness of renewed creation, but it does not wait in vain. We have seen, and we continue to see, God's surprising possibility in our midst.

Will we be courageous enough to recognize God's presence, stand vigil with the newborn and the dying, and cry out for the light? The invitation will meet us again where we least expect it. May God bless the next encounter.

Notes

1. Manny Fernandez, "A Good Day to Speak of Love, from a Rabbi Who Knows Hate and Forgiveness," *New York Times*, January 5, 2009.

Mother

Sally Cunneen

f she had no halo, this woman sheltering her son on her lap might be any mother waiting patiently at a bus stop. Her clothes are hardly fashionable, even a bit foreign, but in our cities today they wouldn't earn a second glance. Neither would her somewhat uncertain ethnicity and race. She could be a visitor, an immigrant, a citizen, her full lips suggesting but not confirming an African inheritance, possibly mediated through Latin American or Middle Eastern channels. Her son suggests an even more mixed background.

But this otherwise unremarkable woman has a large halo. The artist clearly wants us to think of Mary, the mother of Jesus, the woman most notable in artistic history for holding her son, because why otherwise place a dove in her palm? Christians familiar with the Gospel of Luke will recall the new mother's presentation of doves at the temple as prescribed by the law after his birth: "Every firstborn male shall be deemed to belong to the Lord."

Indicating yet another Marian connection through the same symbol, Janet McKenzie has given this dove a halo of its own. The bird sitting so comfortably in this mother's hand recalls as well the intimate relationship between the Holy Spirit and the conception of Mary's child. The angel Gabriel had told the surprised young woman that the Spirit would come upon her and the power of the Most High would overshadow her. Countless paintings of the annunciation remind us of this connection by placing the Holy Spirit in the form of a white dove nearby or above the head of the obedient virgin.

The careful viewer might also notice a row of stylized lilies in a row behind the seated woman. This understated motif is further reinforcement of her Marian identity. Why lilies? They grew in Galilee as well as in Greece, Turkey, and Egypt millennia ago and were mentioned in both the Old and New Testaments

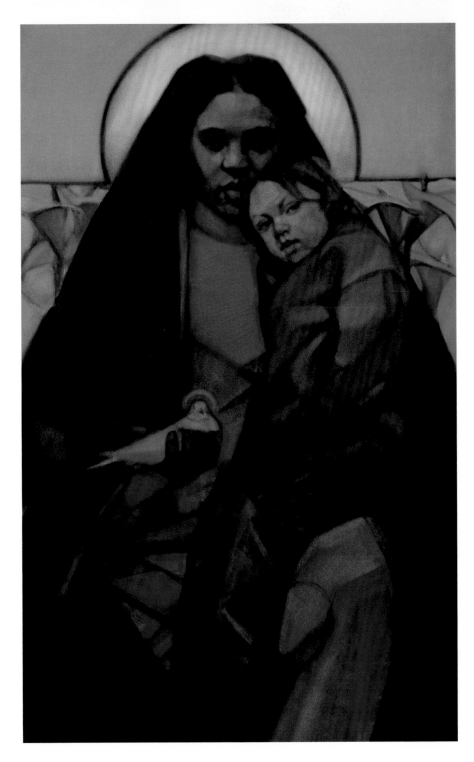

Mother, oil on canvas (30 x 48 in)

Collection of Lorena Chicoye, M.D., Miramar, Florida

before, as tradition says, crusaders introduced them to Europe. In one legend of the annunciation, the angel Gabriel holds a lily in his hand to signify the purity of the young girl to whom he is about to make God's earth-shattering proposal, and the lily continued to appear in paintings of this event down through the centuries. This lovely flower, open to receive both sun and rain, recalled Mary as open to the will of God to the Venerable Bede, Chaucer, and to countless Renaissance and later painters who also saw in its beauty and receptivity a sign of her purity and virginity.

The symbols are here, but it is the figure of the mother and child, as well as their pose and expressions, that capture the eye and dominate this painting. They are both like earlier Marian images and yet deliberately different from them. The pose, for example, is quite traditional. In most early icons, the mother holds her child protectively, often pointing to him to tell us that he is the one to come, the one we have been waiting for. And in countless medieval statues and stained-glass windows, as in the famous Belle Verrière at Chartres Cathedral, Jesus sits on his mother's lap, a child with a mature face. But in those windows and statues, a compassionate, queenly mother is presenting him to the world as its king; he sits up straight, holding a globe or Bible in one hand, and usually blessing us with the other. In contrast, the child in Janet McKenzie's painting leans against his mother, clearly not sure of his role in the world as yet, much like a child of the same age today.

In contrast to Renaissance paintings, this artist makes no attempt to put in a background or provide a realistic perspective. She draws our eyes irresistibly to the gaze of these almost sculpted figures of mother and son, their heads close together, the compelling center of this work. In many traditional icons, notably those depicting the Mother of Tenderness, the baby — a somewhat realistic, happy baby — nuzzles his mother's chin, looking only at her. This Mary, on the other hand, looks out at the world with sorrowful eyes. Her gaze seems fixed just a little beyond us, seeing into her son's future death, no doubt, but also into the mistakes, suffering, and evil that permeate our world, which he is about to enter. She looks at us full of that knowledge and truth, asking us to read her gaze, to accept the awareness that suffering will accompany any joy that even this unique birth — and all others — will face, but she manages at the same time to reassure us of God's unlimited compassion.

This mother's gaze is calmer but no less compelling. She looks straight at us with soft, unblinking eyes, conveying a sense of strong maternal protection. For her child first, of course; she knows he has yet to grow up and know what he is called to do. There is no fear in her eyes. She has confidence in the one she is shielding from the cold and from potentially hostile viewers, and as he stares questioningly at us, he has confidence in her.

But there is more in this mother's direct gaze than inner power and trust in her child. Rather than offering a promise that she can protect and intercede for us, she seems to be asking us to look at her carefully and respond to her. She asks us to take in the reality of her position as a mother, to think how much it will cost in human energy and good will to raise and educate this child. Mary has always represented community among people, not the power of authority; this Mary seems to call on us to become more responsible for one another.

And so, despite the halo, we begin to see how much she is like so many other mothers today, most of whom are not so calm and are often unable to be so protective. The ambiguity of her origins helps us see her as universal, just as Mary has become for believers in the two thousand years since her historical life in Palestine. McKenzie's Mary is a contemporary Mary who reminds us of the motherhood of her God and of the dignity and needs of all mothers today. She blends into them, and they remind us of her.

This is a painting to look at time and again, not only for its arresting presence or the pink background and the blue of Mary's dress, but for the serious challenge this mother's gaze will continue to offer us.

The Family

Judith H. Wellington

amily of courage and love, where is your camp? Where are your grandmothers and grandfathers? Who will help you meet the responsibilities of the day? Who will share your burdens and joys? What is a family without relatives?

You had to leave the land of your ancestors because Joseph was warned in a dream. You escaped the death of your child while others witnessed the massacre of their babes. But now who will assist you in harsh winters or show you the places of water in summer? When your days had been filled with the voices of relatives, how will you find peace in your heart when there are no familiar voices but your own?

What will you find in a strange place where you do not know the Earth, its plant life, or creatures; and they do not know you? Will you be accepted? How will the Giver of life care for you in a strange land? Who will make you their relatives? Will you find a home?

Family of gentleness and strength, you show us how to find love in a broken world. Though you have been driven from your homeland by the cruelty of others, you will return. You will return to live side by side with strangers who do not see you as relatives or as family. You will live among them and your son will reach out to them as though they were his family. He will bring together strangers and outcasts, and he will disturb the powerful. The family meal will be shared with all.

Are we those strangers? Are we the ones who must open the lodge door of our hearts and learn to make relatives? Are we the powerful ones who have forgotten that our actions can save others? You remind us, humble family, that all are relatives to one another. The men are our fathers, uncles, and brothers. The women are our mothers, aunts, and sisters. The children of any are the children of all. We are here to help each other because some of us live in comfort and safety while others do not.

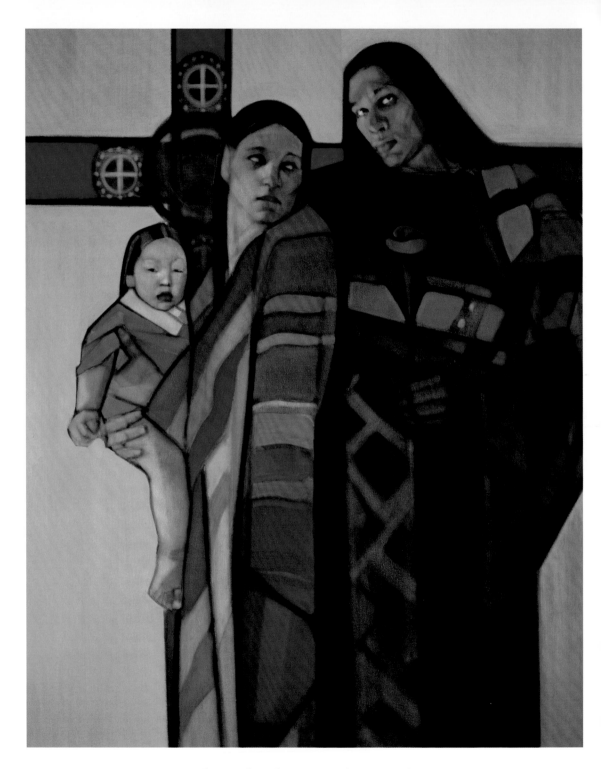

The Family, oil on canvas (42 x 54 in)

Collection of Patti and Richard Gilliam, Sant Fe, New Mexico

The hoop of life has been broken. In this modern world the prosperity of some is tied to the suffering of others. That is not the way of true family. We must mend relationships and find relatives where we did not know them before. We must also see the Earth, the rivers, and the creatures around us as part of this family. Then we will understand the meaning of life-giving power and love.

Family of generosity and humility, you live the prayers you were taught. You know that prayers for your family are prayers for all creation. You know that the gifts of the Earth are to be shared, and you challenge a false security that is fed by greed and pride. You know that we have a common home on this planet and share a common destiny. You remember that in the beginning everything was created first so that humankind, the most vulnerable of beings, could survive. Will we remember that our well-being is connected to the well-being of the Earth?

The Giver of life knows all creation as family. How then can any clan, tribe, or nation be more valuable than another? How can any part of creation be seen as merely a resource for human consumption? How can we claim priorities that undermine relationships of trust? All creation is a gift and all families bear the mark of the Creator's hand. Will we take the time to see it?

We have come so far from a place where grandmothers and grandfathers were needed by the family and where sons and daughters knew aunts, uncles, and cousins. But Joseph took Jesus as his son and showed us that love can make us family where the world sees none. Joseph was not the natural father of Jesus, but he chose to become a father where one was needed. Joseph's strength and manhood were proven by the fire of courage, responsibility, and love.

Will we choose our gadgets and schedules over those who need us to be their family or will we use them to enhance life for all? Will we be able to see relationship as a gift and not just a means to a profitable end? Are we willing to walk the long road of mending the sacred hoop of life? Will we be wise enough to use our creative minds, our compassionate and passionate spirits to meet the needs of our age for the sake of all families? This is not an easy road, but it is a meaningful road. It is the path of becoming a human being. It may be as long as a journey into an unknown land and back again. May we seek the beauty of lifegiving relationships in family and in the creation as we live together on this Earth, our home.

Madonna and Child
with the Origami Angels

(Chung) Hyun Kyung

ere she is. Again. We encounter this young woman at certain corners in Korea, China, Japan, the Philippines, Malaysia, India, Indonesia, Thailand, and many other places in Asia. She is fiercely protective of her child, an illegitimate one in the eyes of her society. The child is not accepted for various reasons. The child might come from a mixture of races, classes, ethnicities, castes, nationalities, religions, or any other dangerous relationship. Perhaps the child might have been born out of wedlock, or be fatherless, homeless, or have AIDS. There is no welcoming place for this young one.

But this mother cherishes her child and holds her tight. She wraps this child with her own shawl in order to cover this Gift of Life from the gazes of ignorant prejudices, the cold wind of the street, and the stones of hatred and anger. She is determined to make life possible for this child, no matter what it will take.

Her eyes are like those of a tiger.

She watches every subtle movement around her, looking for anything that might harm this new life. With her warrior-like gaze, tightly closed lips, and defiant body energy, she guards her child from the "principalities and powers" of the world that create unnecessary suffering. The child is peacefully resting and growing in her protective arms.

Even though the woman is quiet, her entire being shouts:

Chung Hyun Kyung has changed her name to Hyun Kyung, dropping her father's surname in support of the movement of Korean women to abolish patriarchal and patrilineal family law. The meaning of her name in Korean also has been changed by choosing new characters with the same sounds. The former "Jewel of Wisdom" is now "Dark Mirror."

Madonna and Child with the Origami Angels, oil on canvas (30 x 48 in)

Collection of Sally and Don Goodrich, Bennington, Vermont

Ahimsa!
Do not harm.
This is Life.
This is Immanuel.
God with Us.
And . . .
This is God.

Ahimsa!
Do not harm.
Put down your stones.
Accept,
Receive,
Nurture
This Life of God.

Ahimsa!
Do not harm.
If you hurt this child,
You will also hurt yourself.
Open your heart.
Believe.
Ahimsa, Ahimsa, Ahimsa. . . .

In her we recognize, remember, and feel the warrior goddesses Durga and Kali. Together they alert us to the presence of the "kin-dom of God" here among us. They invite us to see, feel, and participate in bringing a fuller justice to our Earth, a justice of "right relationships" in a "feast of equals."

Her black veil and shawl are symbols of her bondage and oppression, the tools invented by men who want her invisible, limited, and closed. These men want more power, more control and domination over all living beings. They use unjust laws and traditions, weapons and violence to subdue the Life Force, which is not controllable.

Nonetheless, she wears these symbols. They are part of her survival strategy and her bargaining tools. She is aware of the enormously harmful ignorance of

men of power. She also knows that the most dangerous thing in the world is power accompanied by ignorance, power without wisdom. She is waiting for her time to wake them up and bring them to knowledge. If it is prematurely forced on them, these men can become even more violent out of their insecurity and lack of control. Her wisdom and compassion make her patient, skillful, and able to do the right thing at the right time. She embodies the wisdom that has been transmitted from mothers to daughters for thousands of years in Asia, the wisdom we call "kitchen fire wisdom":

> Learn from the water.
> Water seems soft, yielding, and flexible.
> Millions of drops of water, however, make a hole in the rock.
> Do not fight directly.
> Remember your truth always, your inner light and power.
> Be persistent.
> Come back millions of times to do what you need to do.
> *Oe yu nae kang,* outside gentle, inside strong.
> This is the way of sure transformation.

She is a spring of water, a well that never dries up. People come to drink from her spring of life. Her Living Water quenches the thirst of all sentient beings. She is also spring that blooms. She brings back Life over and over again after the long death-like winter. She is Mother Earth, Gaia, Pacha Mama, and Mago, the Korean goddess of creation.

She is a fertile virgin. She gives birth but remains ever a virgin because she does not belong to any man or any patriarchal order. Her being is free. She is who she is. She belongs to God. She belongs to all that is.

Her aura is pink. Here blood and milk are mixed. She has seen much shedding of blood in her sea of suffering. Her every cell knows that "life is suffering." And she knows that we create suffering out of our ignorance, greed, and hatred. It is our original sin, our "original condition-ing" of wrong-thinking, of dualism, of hierarchical presuppositions and binary logic: you must win or lose; it is either/or; a person is friend or enemy, the dominator or the dominated. And our wrong-thinking includes racism, sexism, classism, castism, able-bodyism, heterosexism.

All these binary divisions and separations that we use to make us different from others cause us to suffer.

We then project our fear on those who are different from us. We are uncomfortable with differences, yet it is the unknown that challenges us to come out from our comfortable world of complacency. When we are not open and when we are unwilling to jump into the unknown out of fear that it might change us, our deep fear and unease force themselves into our unconsciousness. These pushed-away

thoughts and feelings become a dark shadow that follows us everywhere we go, a shadow that lurks in and around our being like a hungry ghost

When these hungry ghosts are triggered by fear, anger, or hatred, they become harmful. They tempt us to keep at a distance all the sentient beings that are different from us. They suck up our energy. The hungry ghosts teach us to fear as they whisper to us, "Those people — or countries or religions or different ways of doing things — are evil. They are extremely dangerous. They are terrorists. They will come and get us. They are demons. Eliminate them! Cast them out! Kill them! Let us bomb their homes and cities!" The label of "Other!" leads to demonization. Demonization, in turn, leads to attempts to destroy. And we end up with the Holocaust, ethnic cleansing, massacres, and full-blown war. Cause and effect, cause and effect, cause and effect. Alas, Samsara, the wheel of suffering, continues.

In the midst of Samsara, this mother stands, still holding her child tightly as she witnesses the sea of suffering. She knows she cannot stop the killing fields, but nonetheless she accompanies us in the valleys of death with her loving and compassionate presence. She suffers, wails, and weeps with us. She dies with us, and then she rises out of the valley of death. She comes back with a child, New Life, with her breast full of milk. Her breast milk spreads out over the killing fields to fertilize the death valleys so that "life abundant" is once more possible.

She prays that we will finally understand the uselessness of greed, hatred, anger, war, and violence. It is, however, our own lesson to learn, and she will not force

us. She understands the futility of force. We must experience a genuine awakening so that we will not repeat our mistakes out of the sheer power of habit. Her pink aura, this mixture of blood and milk, reminds us of her compassionate wisdom, her all-seeing eyes, and her thousands of hands to help. In her, we see Kwan In, the goddess of compassionate wisdom who hears the cries of the world, and Tara, Mother of all Buddhas, who lets us bloom like a lotus from the muddy water of our being.

In Asia, we fold paper cranes to help God hear our prayers, our deepest longings and hopes. Japanese children in Hiroshima and Nagasaki have folded a thousand paper cranes as a prayer that they will never again experience the horror of nuclear destruction in their land or anywhere on this green Earth. Korean children fold paper cranes for the unification of North and South Korea so that the people of the two countries may live in peace without war. Filipino children in a slum fold a thousand cranes for healing from incurable diseases and poverty. Indonesian children fold a thousand cranes so that adults will not fight in the name of religion. Chinese women fold a thousand paper cranes for needed love. Soldiers on the battlefields fold a thousand paper cranes from their cigarette packages so that they might return home alive.

With the origami cranes behind them, showing the folding and unfolding of peace, justice, and reconciliation, this dark Madonna with her child appears in a soft light of healing, wholeness, and transformation. This dark Madonna has been and is with us as Ishtar, Isis, Diana, Artemis, Yemaya, Ochung, Our Lady of Tindari, Einsiedeln, Chartres, Montserrat, and Guadalupe, transforming our bleeding hearts and bodies into those of healers, peacemakers, Earth protectors, and community builders with her power of ever flowing milk. Her alchemic power of transformation turns our chains of oppression into gold in a beautiful celebration of life. She whispers to us with her calm and small voice, "Don't be discouraged. In the end, the Gift of Life will save us all."

Sacred Madonna and Child

Joyce Rupp

nlike the soft and sometimes saccharine portrayals of Madonna and Child, this depiction of Janet McKenzie's immediately captures my attention. The child's face forms the central focus. An old soul peers out of young eyes. His facial features tell of an inherent wisdom far beyond physical years. This innate perception reveals itself in the child's fearful gaze. His watchful eyes look beyond the lap of the mother. They convey a recognition of something ominous lurking just out of reach. Yet he is but a child, and in his youthful vulnerability he clutches at the Mother's clothing, pressing his body close to hers, a maternal safety he clearly trusts.

Although the Madonna's eyes are closed, her countenance reveals the full concentration she places on her child. Her face with its wide, slightly furrowed brow bends downward toward her son, but instead of a contented mother's smile, her expression shows hints of apprehension. The Mother's acute attentiveness implies that she, too, senses there is danger beyond the two of them. She can feel it moving through her beloved child into her own heart. In her motherly closeness with the child who once filled her womb, she cannot help but breathe in his fear and concern. In spite of this uneasiness, there also appears a certain calmness in her visage.

The strength of the Madonna's external features indicates an inner resiliency. The Mother's sturdy right hand points toward her apprehensive child while her muscular left hand spreads out as far as it possibly can to hold on to him. Her strong posture confirms the committed power of her protective love. This is no frail, helpless mother. Every aspect of her demeanor indicates she is fully bound to this child, ready to willingly give the entirety of her life to save him from what he fears.

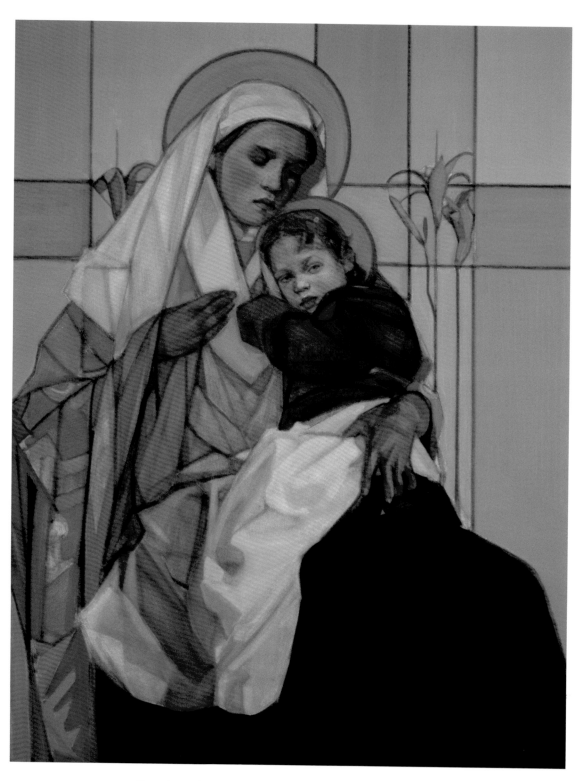

Sacred Madonna and Child, oil on canvas (36 x 48 in)

The *Sacred Madonna and Child* presents a teenage mother with an old-looking child who knows far too much. The wide swath of a cross forms the background for these two poignant figures. Neither sees the cross, but what the child does see will eventually pin him to that cross and break his mother's heart.

Numerous questions surfaced as I gazed on this painting. What does the child see? How does the Mother feel? Are these two silently communicating with one another? If they could speak, what might they be saying? Perhaps their dialogue would be something like the following.

Mother, when I look out into the world, I see things that scare me. Why are people hurting one another? What makes them do mean things? Where are the fathers and mothers of the little children who are crying? Why do some persons have lots of food and water and others none at all? I don't want to grow up in a place like this. Will I be hurt, too, Mother?

Oh, dear child, your fear pierces my heart. There is so much cruelty and pain in this world of ours. I long to have brought you into a life without suffering. I want to hide you from this part of existence. You are much too young to carry the weight of what you see. You are too innocent for humanity's selfishness and injustice to press upon you. I want to shield you from the harshness of this part of life, to turn you away from what your young eyes and unblemished mind behold.

But, Mother, why? Why is the world this way? I am afraid to live in this place. I wish I could go back and make my home in your womb. In there I lived in a happy place of safety and love. I heard you sing to me as you kneaded the family's bread and washed clothes in the river. I felt your comforting peace when you lit the candles and paused for Shabbat prayer. I remember the kindness in Aunt Elizabeth's voice and the laughter of the two of you as you worked in the garden. I didn't know, then, that there was anything more than happiness. Oh, Mother, I loved being inside your womb.

If I could do so, I'd change this world instantly for you, my little one. I cannot do that. What I can do is promise that I will never leave you. I will care for and keep you as safe as I possibly can. I'll always be here for you. I love you, dear child.

Mother, when I hear you say that, I feel less anxious, less afraid.

My child, in the beginning I wasn't this calm. Before you were born I, too, was afraid. I worried about all sorts of things. I couldn't imagine how I might be the one to bring you into life. I questioned what would happen to me and doubted my ability and worthiness to be your mother. But do you know what happened? Gradually, I became convinced that Someone much greater than I would see me though my pregnancy with you. The Voice I heard in the deepest part of my soul offered such magnificent reassurance that I grew peaceful and trusting. This is what helps me believe you will have the courage to see you through whatever comes.

Are you sure, Mother? Remember the terrible nightmares that awaken me and scare me — how I see sad people, sick and dying ones, angry faces? They seem so real to me.

Dear child, you already have a passionate sensitivity to the pain of others. I think it will be your greatest blessing as you grow up, but it will also be your deepest distress. Let me tell you the story of how you came to birth. It might help you trust your inner strength. Did you know that your foster-father Joseph and I were scared to death when we realized it was time for your birth? Joseph and I didn't know where we could stay or if there would be anyone to help, but God led us to a quiet place. When I felt you starting to push your way out of me, I was terrified that both you and I would die. Only animals and angels were there when Joseph lifted you into my waiting arms. I gazed at your beautiful, soft body and could not contain my joy. I wept and wept with happiness and relief. Your foster-father and I both looked upon you with awe. We promised each other, then and there, that we would do everything possible to help you with your work in the world.

My work? What will that be, Mother? Will I be able to help people who hurt?

I'm not sure, dear one, but I think you will make a big difference in their lives. The angel who told me I was pregnant also insisted you are destined to be a great influence in our world. My intuition tells me you are going to help a lot of people. Do you know what I feel when I hold you? It's like having the sun near my heart. There's an intense warmth in you that could set the world on fire. Do you remember how I talked with you about this love that we have deep inside of us, where only good can live? Everyone has this amazing gift of the Holy One dwelling deep inside of them. Little one, let us breathe this love out into our world. The

more we share our love, the more it can change the worst desperation and the most armored heart. You and I may never see this happen but I believe that someday what you see before you now will be changed by this immense love. I can tell you are filled with this love. When I hold you near, your love embraces me so fully that my whole being wants to bow before its beauty and power.

Oh, Mother, I will trust you and this deep love within me, no matter what.

Someday all of life will be in harmony. People will dwell in peace. Let's hold this hope in our hearts, my beloved child. Let's give ourselves as fully as possible to those who cry out for the precious gift of love. We will keep turning to the Holy One every day and draw our strength from that eternal source. Remember your heart is always united with the Holy One. You will never be alone.

As I imagined this conversation between mother and son, it occurred to me how *Sacred Madonna and Child* depicts not only the divine child, who eventually absorbs the world's pain and dies the death of a convicted criminal, but it also portrays each person today who experiences the suffering of a wounded world. Janet McKenzie's Madonna and Child are every person who endures the atrocities of war, greed, abuse, disease, and oppression. Through her insightful and compassionate portrayal of these two scriptural and historical figures, the artist reminds us that we live in a world containing a huge amount of pain. The only way this world will be transformed is through our personal activation of the Great Love dwelling within each of us.

Jesus of the People

Elizabeth A. Johnson

f you happened to miss the wispy thorns and if you didn't know from the title of this painting that this was Jesus, you might never guess. In place of the white male figure of Western European heritage depicted in Hollywood film and popular religious art, and in place of the Mediterranean Jewish prophet that historical imagination can conjure up, we see an unexpected figure gazing at us: androgynous, mulatto, framed by symbols of indigenous and Eastern religions. The artist, Janet McKenzie, has shared the meaning that flowed through her as she painted: "The essence of this work is simply that Jesus is all of us."

You might wonder whether this is just a wild and wooly artist communicating some outrageous opinion. Or you might ask whether there could be truth to this idea.

On the trail of that question, if you traveled back to the early centuries of Christian belief, you would discover that this insight, "Jesus is all of us," was the subject of fierce, churchwide debate across three continents. Perhaps surprisingly, this wisdom ended up being defended by all the forces of orthodoxy. Connecting that ancient fight with this evocative painting can uncover a subversive truth that still needs believing.

The problem, as phrased in those days, was that Jesus could not possibly be truly human. Being human meant being a finite creature, first of all, with a fleshy body subject to hunger, sexual arousal, pain, and death, the very opposite of divinity. More troubling still, it meant having a soul whose powers of knowing and choosing were limited. Worst of all, being human meant being ensnared in a history of sin. To think that Jesus shared these conditions was blasphemous. One who was God's own child could not be contaminated by this finite, fleshy, sinful mess.

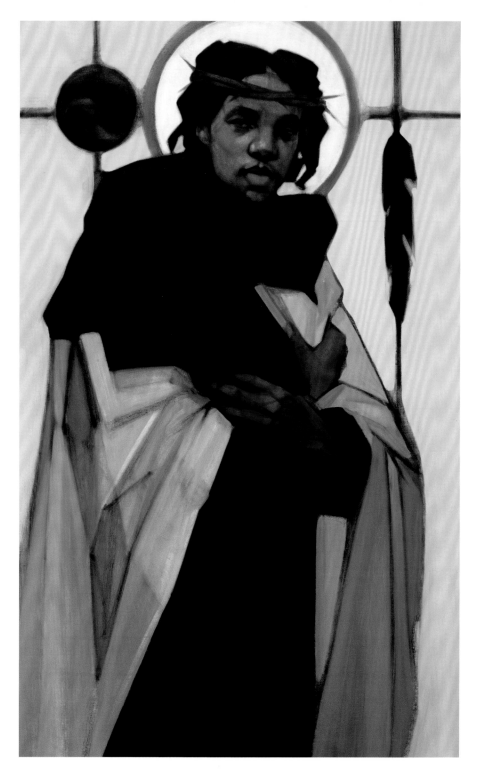

Jesus of the People, oil on canvas (30 x 48 in)

Therefore, so the argument went, his human nature had to be merely an appearance, something like an external suit of clothes stepped into in the morning and easily shucked off at night. This human costume enabled Jesus to be seen and heard so that a divine message could reach the world. But, like Superman, although he looked human on the outside, he actually had secret "souped-up" insides. He wasn't one of us, let alone "all of us." It got to the point where even Jesus' death became suspect. One early theologian wrote that the nails pierced Christ's flesh the way an object passes through the air, painlessly. What was the point of the cross then? To show us an example of obedience.

In this debate the stakes were very high. According to an ancient axiom, "What is not assumed is not redeemed." If Jesus' humanity were a pretense, then the good news of divine compassion that he embodied was likewise a sham; we are not touched in the depth of our need.

The conflict's resolution, hammered out over centuries, came down strong for Jesus' identity as one with all of us. We can hear its clarion tones in the Nicene Creed still recited across the divided churches today. At the climactic moment, the creed confesses that the one who is Light from Light "became human." In Latin, the precise words are *et homo factus est,* "and human he was made" in literal English translation.

The choice of the inclusive word *homo* was not accidental. Latin has words that specify persons according to their gender: *vir* (man) and *femina* (woman). But the debate had not revolved around his gender, let alone his race, ethnicity, sexual orientation, economic class, or any of the other markers that identified him as a particular human being. The core question was whether he could be counted among the human race. So the creed sings that he became *homo,* human, not *vir,* not *Iudaeus* (Jew), not *tignarius* (carpenter), not *pauper* (a poor person), though he was all these things, but *homo,* one of all of us as a human species. Thanks to this connection, the whole human race has been touched by grace in a new and loving way.

In historical context, the choice of *homo* makes clear that it is not Jesus' maleness that is doctrinally important, nor his Jewish ethnicity, nor other specific characteristics, but his genuine humanity. While Jesus was indeed a first-century Galilean man, and thus irredeemably particular, what counts is his embrace of humanity in solidarity with suffering persons of all races and historical conditions. Amazing

grace flows through him not thanks to his maleness but to his liberating love lived in the midst of historical evil and oppression and set loose upon others by the power of the Spirit. In face of this, the trivializing of Jesus' humanity, introduced by interpretations that foreclose certain groups from full participation in his community, such as the idea that women cannot represent Christ at the Eucharist, fully warrant the charge of heresy. The intent of christological doctrine was and continues to be inclusive.

"Jesus is all of us." How far does this reach? Your eye might be caught by the feather in this painting, a feather that comes from a bird. Together with the *yin-yang* symbol of cosmic harmony, it draws our insight to a yet greater inclusiveness. Thanks to contemporary studies of the cosmos and of evolutionary biology, it has become impossible to define people realistically apart from the natural world. Our very flesh, as scientific discovery makes clear, shares a history with otherkind that reaches back through ancient life-forms on Earth and into the stars, back to the beginnings of the primeval fireball itself. What makes our blood red? Arthur Peacocke, a scientist who is also a theologian, explains, "Every atom of iron in our blood would not be there had it not been produced in some galactic explosion billions of years ago and eventually condensed to form the iron in the crust of the earth from which we have emerged." Quite literally, human beings are made of stardust. Furthermore, the story of life's evolution makes evident that we share with all other living creatures on our planet a common genetic ancestry. Bacteria, pine trees, blueberries, horses, the great gray whales: we are all kin in the intricate, awesome community of life.

Hence the "all of us," still not established securely enough among human beings, now stretches deeply across the species line to encompass the Earth itself and its beautiful, wily, distressed myriads of creatures. "Who is my neighbor?" That ancient challenge to Jesus was met with his parable of the Good Samaritan. Today his words echo in a new cadence with the reply: "The Samaritan? The outcast? The enemy? Yes, yes, of course. But your neighbor is also the whale, the dolphin, and the rain forest. Your neighbor is the entire community of life, the entire universe. You must love it as your very self."

Present as a gift from God, Jesus, too, is part of this history of the cosmos in its finitude, emergence, and perishing. Born of a woman and the Hebrew gene pool, his embodied self was a complex unit of minerals and fluids, an item in

the carbon, oxygen, and nitrogen cycles, a moment in the biological evolution of this planet. The atoms comprising his body were once part of other creatures. The genetic structure of the cells in his body were kin to the grasses, the fish, the whole community of life descended from common ancestors in the ancient seas. In his person, gracious solidarity encompasses not only all people but the whole biological world of living creatures and the cosmic dust of which they are composed.

When the noted U.S. naturalist John Muir came across a dead bear in Yosemite, he bitterly complained about those whose belief had no room in heaven for such a noble creature: "Not content with taking all of earth, they also claim the celestial country as the only ones who possess the kinds of souls for which that imponderable empire was planned." To the contrary, he figured, God's "charity is broad enough for bears."

Drawn into an ecological framework, this painting leads to the same wonderful conclusion. This human person, Jesus of Nazareth, composed of star-stuff and earth-stuff, existed in a network of relationships extending through the biological community of Earth to the whole physical universe. If such "a piece of this world, real to the core," real to the point even of dying, has been transformed, *risen,* by the embrace of the Creator Spirit, this signals a hopeful future not only for all people but for the cosmos itself. The whole natural world, all of matter in its endless permutations, all sister and brother species, will not be left behind but will be encompassed by the gracious love of the God of life.

Jesus of the People, writes the artist, pays homage to two groups traditionally marginalized with regard to the physicality of Jesus: people of color and women. It does so poignantly and with power. In its own intuitive way, it also honors the natural world in which all people are embedded, from which they cannot be separated, and for which they are responsible. It rearranges the landscape of our imagination to know that human connection to nature is so deep that we cannot properly define our identity without including the whole great sweep of cosmic evolution. The love of "Jesus of the People" embraces the flourishing of all peoples and the whole Earth itself. Indeed, "all of us."

Jesus of the People

(Chung) Hyun Kyung

e stands on 125th Street in Harlem, leaning against a tree. His dreadlocks, his worker's body, and his sad bruised face tell a story, and his blood-stained hands tremble. "Are you okay?" I ask. He nods his head without saying anything.

"Do you need help?" He nods again, no words.

I examine his hands. He has a deep cut. The bleeding has not stopped.

"Oh, God! We have to call 911."

"Please, don't!"

Then he runs across the street and disappears into a small side street.

I feel so bad. What did I do wrong? I hope he is okay. His sad and kind eyes stay with me. Who is he? Why is he bleeding? Why doesn't he want help from the police?

He is suffering. I regret my inaction.

I didn't know how to help him, and now I'm so sorry.

How many young black men have been harassed by the police in New York City? How many of them are in prison and not in school or college? So many young men with dark skin are bleeding now in the United States, and in Afghanistan, Iraq, Palestine, Darfur, and Guantanamo Bay. The power of empire is unceasing and seems to grow even stronger. Many dark-skinned young men are now being arrested as terrorists, as possible criminals or enemies of the state. These young men and their communities still carry the cross of an empire that thrives in its limitless greed for wealth and power.

I grew up in a Presbyterian church in Korea, a century-old mission church. All the pictures of Jesus in my childhood were of a very white, very blond and blue-eyed Jesus. It was inscribed deeply in my young soul that the lighter your skin, the closer you are to God. That God's only son was so white had to mean that God

74

must be even whiter than Jesus. We simply assumed that God is light, and light itself is white. Therefore, God is white, and white is God. God is also powerful. White, therefore, represents power.

These unconscious messages have been accepted as a given truth in many parts of the world, especially in the Western world after Christianity became the official religion of the Roman Empire. Over millennia the Christian God has been portrayed in the image of kings, conquerors, and colonizers. It has taken almost two millennia to reimagine God and Jesus other than white.

Thanks to the rise of liberation theology, black theology, feminist theology, Asian theology, African theology, Indigenous theology, womanist theology, *mujerista* theology, and queer theology, we can now reimagine Jesus and declare that Jesus is a *campesino*, black, female, Asian, African, Indigenous, Hispanic, or queer. Dozens of images of Jesus have blossomed during the second half of the twentieth century. The appearance of Jesus does matter because we believe in an incarnated, embodied God. If the core of Christian doctrine is the incarnation of God in Jesus, everything about the human-ness of Jesus — skin color, sex, age, ethnicity — matters and determines our response to his concrete historical embodiment.

Kim Chi Ha, a revolutionary Korean poet, wrote a long poem titled "The Gold Crowned Jesus." It was a satire about large, membership-oriented Korean churches, which were shamelessly pro-capitalist, pro-USA, and pro-authority, even though the government at the time was a brutal military dictatorship. Kim portrayed Jesus as the prisoner of these greedy churches that adorned him with gold but suffocated him with their false power. Wearing a gold crown, he cried out in the prison of the church, "Please release me. Is there anybody who can liberate me from this prison?"

Kim Chi Ha was arrested many times by the dictatorship, and he was interrogated, tortured, tried, imprisoned, and even received a death sentence. His poetry became a source of inspiration for the movement known as Korean *minjung* theology, which arose from the struggle of Korea's oppressed people and their yearning for a just society. *Minjung* theologians understand Jesus not as a single heroic individual but as a collective of people who fight for the reign of God so that all people can experience the fullness of life. This is a "people power" Jesus!

Sweet Honey in the Rock, an African American choral group, sings, "We are the people we have been waiting for." The lived wisdom of African Americans is that they can no longer wait for a Messiah to be their rescuer. We all know of horrendous evil — the genocide of indigenous people, witch-hunting, slavery, the Holocaust, atomic bombs — and we have found no intellectually satisfying answers to the age-old question of why a good and just God allows so much evil and injustice. After generations of waiting, many people have come to terms with the reality of this "not coming" and changed their outlook. Now they look around their world with new eyes and realize that the Messiah is already here within, between, among, and around them. They experience the Messiah alive and growing when they come together with their own power to live out the Gospel values. The birth and growth of a "collective Messiah," a people's Messiah, comes about when right relationships are embodied and permeate every sector of our human community.

Let us return to the young black man with dreadlocks. He understands what we Koreans call *han,* our accumulated anger, sorrow, despair, depression, and hope-lessness. I could see it in his face. The feeling of *han* is like a cancer in one's soul. As I reflect now on his face and body, I realize that we do understand each other, even though we come from far different corners of the world.

In *Jesus of the People* I also see a young black man whose blood-stained hands and his thorny crown are signs of *han.* His black and white garment is a symbol of his struggle as is the symbol of *yin* and *yang* behind him. But he transcends them as he rises and flies toward God with his soul's feather. In his new state, his life-giving energy pours out to all who need it.

I hope I can meet the young black man with the dreadlocks and blood-stained hands again. I will do better this time. We must meet again so that God can grow through us and with us.

Jesus at Gethsemane

Helen Prejean

cce homo. Look at the man. Look at his face. At first glance his face looks serene. Look closer. He is undergoing a soul agony so intense that he sweats blood. Look at his cowl wrapped close, his downcast eyes, shuttering from view his fierce inner struggle: a young man wanting to live with every sinew of his being but faced with imminent torture and death. He struggles to embrace the message he preached on Galilean hillsides: *unless the grain of wheat falls to the ground and dies.*

He's only in his early thirties. He's barely had three years to inaugurate the mission he received from his Father. His disciples are having a hard time getting the mission right. When he says "kingdom" they have their own ideas. He knows that on the road, trailing behind him, they argue fiercely, jostling for the highest positions. It worries him. It wearies him. And now as he prays, he prays alone. They have fallen asleep.

The Letter to the Hebrews records his agony: "With loud cries and in silent tears he pleaded with his Father to save him from death. . . . Though he was Son he learned obedience from suffering" (Hebrews 5:7–8).

Lloyd LeBlanc kneels in prayer in a small Catholic chapel in St. Martinville, Louisiana.

I kneel beside him, praying the rosary. It's Friday, so we pray the sorrowful mysteries in Christ's life, his agony in the garden, his death at the hands of cruel men. Lloyd LeBlanc relives his son David's terror in the darkness of night in a sugarcane field when he and his girlfriend were abducted and killed by Patrick Sonnier and his brother. He last saw David alive on a November night in the kitchen of their home before he left for a football game. When his son had not returned home by 3:00 a.m. Lloyd and his wife, Eula, were pacing the floor, making phone calls, praying, dreading, waiting.

77

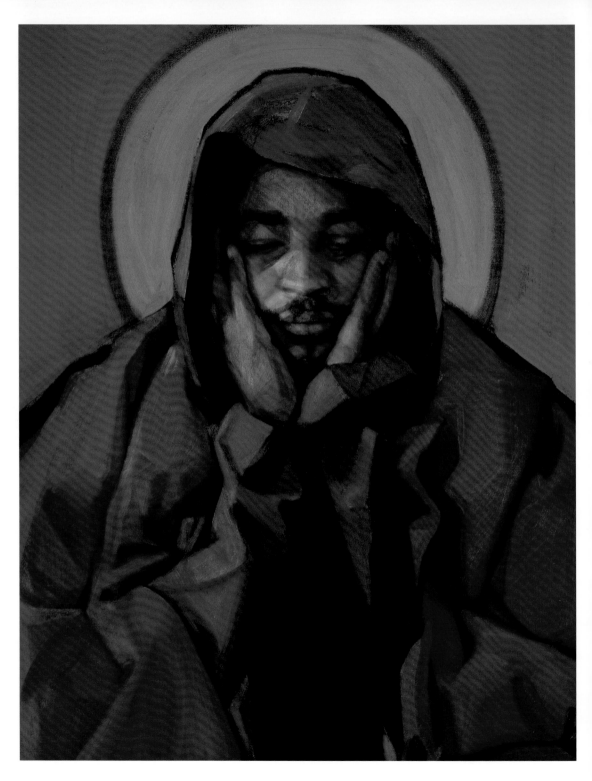

Jesus at Gethsemane, oil on canvas (20 x 24 in)

His worst nightmare became reality when a sheriff's deputy appeared at his door the next day and asked him to come to the town's morgue to identify the body of his son. Lloyd prayed for grace: grace to accept God's will, grace to help Eula and his daughter, Vicki, grace to overcome feelings of bitterness and hatred. From the impact of bullets to the back of his head his son's eyes protruded "like two little bullets." Lloyd said the Our Father over the body of his son, prayed the words he learned from his good mother, the words he said at Mass every Sunday, and when he got to the words, "Forgive us our trespasses as we forgive . . ." he said the words and set his soul to try to live them, to follow the way of Jesus, the way of forgiveness.

It took a while.

"I prayed and prayed," Lloyd said, "not to hate. But, see, I've always been kind to people. I like to do things for people; it's just who I am. And I decided: they killed my boy but I'm not going to let them kill me. If I hate, I'll be dead too."

And so Lloyd LeBlanc set his face to walk the road of forgiveness, and God's grace met him on that road, and he forgave the men who killed his son.

Recently Lloyd LeBlanc died. When he was buried, his son's body was placed in the coffin with him. His wife, Eula, who has now lost her son and her husband to death, takes comfort that David rests in his father's arms and that Lloyd, her husband, does too.

Patrick Sonnier is in the death house of Louisiana, three hours away from death. They will soon strap him into an oaken chair, fashioned from limbs of a tree (the tree is innocent) and pump fourteen hundred volts of electricity through his body. I am with him, seated on one side of a metal door, he on the other, a mesh window between us through which we talk and pray and sometimes I put my hand on one side of the mesh and he puts his hand on the other and our fingertips can touch a bit, the only way I can touch him. He has said that's been the hardest thing on death row: no one ever touches him. He has been convicted of killing two teenagers. In cold blood. Shot them in the back of the head execution style. He cries out in remorse to God for his great sin. When guards dim the lights on the tier at midnight he kneels by his bunk and prays for the parents of the teenagers. He hates what he has done. He prays to Christ for mercy. As we wait now in the final hours, he finds words to pray from Psalm 31: "O God, they plot to take my life . . . but you are my rock; on you I stand." I pray, O Christ, be with him now.

He says, "Just pray God holds up my legs as I walk." I say, "When they do this, Patrick, look at my face, I will be the face of Christ for you."

It has been anticipating death that torments him, the same nightmare comes: the guards are coming for me, it's my time, I struggle — kicking, sweating, shouting as they drag me from my cell: "No! No! Don't kill me! Please, I want to live!"

He wakes up. It's only a dream. He looks around his cell. He's still alive. Later the execution squad will come for him. Inside himself, bracing for death, he dies a thousand times before he dies.

Ecce homo. Look again at the suffering face.

Look deeper. Not with bodily eyes but with eyes of soul, of prayer, of holy longing. Gaze at him in patient waiting. Gaze and pray for grace to enter into his Presence. Perhaps he will speak to you. Perhaps you gaze and feel nothing, see nothing. Which means you must leave and come back and gaze again. Perhaps you will be given the grace to feel his gaze, to know in the deeps of your soul that he is looking at you. And when you know his gaze, you will never be the same again. One way of knowing he has truly looked at you is that you recognize his suffering in others. Not only in people close to you, but in strangers, in scary foreigners, in criminals, in drunks sleeping in doorways.

> *I greet him the days I meet him and bless when I understand.*
> — Gerard Manley Hopkins

Woman Offered #5

Diana L. Hayes

rom time immemorial, women, of all races and ethnicities, of all classes, have been nailed to the cross of Jesus Christ. Willingly, even eagerly, some have climbed up and hung, believing that in doing so their sacrifice of love, their martyrdom, will protect them, their families, and especially their children. Others, unwilling and unasked, have been forced onto their crosses by those they love and by the societies in which they live, again for their own protection and the good of society. In reality, they are crucified solely because they are women and that, the world teaches, is the role of women, to sacrifice themselves, their hopes, dreams, and aspirations for everyone.

Come down from the cross! If Jesus were to return today, would these not be some of the first words he would say to our world? "Come down; stop sacrificing yourselves for your alleged sins and those of others. It is no sin to be a woman; it is a grace, given by God. I died so that no one, no one, would ever have to suffer the cruel pain of crucifixion, of dying, hanging from a tree, stabbed, starved, laughed at and derided. Come down off that cross, now! Do not wait for others to take you down; you have the right and the ability to stop your suffering yourself! Come down!"

Too many women have been "surrogate sufferers," forced to live lives of sacrifice and self-effacement for the supposed good of others, especially their men, rather than being able to freely choose paths of their own making, lives of their own choosing, futures of their own desiring. They have been placed on crosses, however they may be named, that imprison rather than liberate, that impede rather than promote, that weaken rather than empower, and that cripple rather than strengthen. Motherhood and martyrdom, the virgin or the whore, these have been the extremely limited roles available to women. Any woman who chooses another way, seeking to serve God in her own right, whether by remaining single

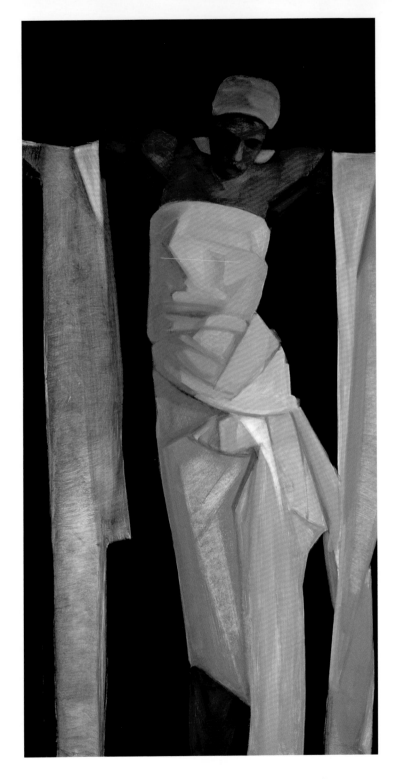

Woman Offered #5, oil on board (24 x 48 in)

but not in religious life, by seeking further education beyond domestic skills or approved women's fields that initially, like nursing and teaching, were also forbidden to them, is condemned as "unnatural," prideful, and even persecuted as a witch.

The cross has become historically not a symbol of a once and for all freely given sacrifice of life and love but a punishment for women, the poor, persons of color, all and any who dare to be different because they are born different, as we all are born. Those historically marginalized and made voiceless in our world, the majority of whom are women, must now step down from the cross. This is not why Jesus died and rose again. He died and rose again to give life, not take it away. He died to open up our lives to their limitless possibilities and not to restrict them by negativity, self-doubt, or fear.

Women have been condemned for their intelligence, for their sexuality, for their emotions, all gifts given to them in their creation by a God of love and compassion. God created women not as scapegoats or footstools, not as baby-making machines or mindless beings, robots without wills of their own. No. God created woman to work in solidarity with God's other creation, man; to stand alongside and not in back or in front of him, to care for all of God's creation. Both creation stories confirm this. The first chapter of Genesis states that God created male and female at the same time as the pinnacle of God's creation (Genesis 1:26), to nurture and sustain it, not to dominate or destroy it. But many know nothing of this story because the emphasis of Christian churches has always been on the story of Adam and Eve.

Even there we do not find a mandate for woman to be submissive to the will of man. Both are meant to submit to the will of God and both fail to do so, in their own way. Eve is Adam's help-mate, a term too often misinterpreted as servant or slave, rather than one who works in harmony with him as an equal. They do not have ownership of each other or of God's creation; they are stewards, not masters. They have the ability, by the grace of God, to think for themselves and, in doing so, as many of us finite humans continue to do to this day, they strayed from God's path. They were punished by banishment but they were not cursed. More importantly, their banishment freed them to create life themselves in their own image and likeness and that of God's, again by the compassionate grace of God. They were freed to cultivate the land, to attain knowledge of themselves and the

world around them. In other words, they were freed to be human. Eve was not the source of evil or the gateway to hell. She was and continues to be the source of life as we have come to know it in its purest and fullest sense.

Women are the bearers of life and culture. They tell the stories, sing the songs, reweave the tapestries of our lives, and pass on knowledge of life and the world around them to all of humanity. Their gifts should be celebrated rather than condemned, rewarded rather than punished, proclaimed rather than ignored. Jesus himself proclaimed in Mark 14:9 of the unknown woman who anointed him, "I assure you that wherever the gospel is preached all over the world, what she has done will be told in memory of her."

The Gospel has been preached for two millennia but somehow this passage has been ignored, much in the same way that the role of women in Jesus' ministry and their proclaiming of the Gospel message have been ignored. Instead, we hear only of women who are sinners or martyrs, virgins or whores. Where are the real women living real lives of love, friendship, study, writing, preaching, prophesying, dancing, praying, and singing? We know little of them.

Women, of every race and nation, have carried the weight of the world on their shoulders from time immemorial. They have suffered long enough for the sins and failings of everyone. It is time, long past time, for them to come down from the cross and walk freely into new life, a life of possibility, not pain, of progress, not false failures. This does not mean that they can walk away from responsibility toward themselves and others but that they have the freedom to choose for themselves the paths they should take, the lives they should lead, the tapestries they will weave. All adults, male and female, should be free to choose. They are free to envision different possibilities for themselves and, therefore, for those they love.

Woman! Come down from that cross! It is not yours to bear. Jesus was nailed to the cross, died, and rose again, making the cross a symbol of resurrection, not of pain or death. Lift up your head, look the world straight in the eye, and come down from the cross to take up your life as God's beloved, weaving a new world, free of pain and suffering, hatred, prejudice and discrimination, oppression and marginalization, into a new, complex, and fruitful life.

Come down!

Mary, a Mother's Sorrow

Paula D'Arcy

 hen I first looked at this image of Mary's sorrow my heart flashed back to a moment when I sat with a friend following the loss of her only son. I had visited many times during her initial weeks of grief, but on this particular occasion she had a specific request. She wanted me to be present as she opened, finally, the bag given to her on the night her son was killed. In the bag were his personal belongings, including the last clothing he'd been wearing.

I arrived in the early afternoon and she motioned for me to follow her to a small sitting room. Her footfalls were heavy on the stairs. From a small closet behind the couch she tenderly lifted the plastic bag the hospital had handed her months before. She sat with the bag across her lap for thirty minutes. I glanced over her shoulder to the window. A single deer walked slowly through the back yard nibbling grass.

Then I heard a moan so small it hammered me. I wasn't sure if I'd ever felt closer to another human being. I watched as her delicate fingers untied the plastic knot and carefully removed her son's shirt. She handled it with the care of someone who confronts a great mystery for the first time. The shirt lay between us like an axe — rumpled cotton capable of pounding your life into a different shape. Thin slants of light fell across her face, but not a visible tear. The tears were boiling inside of her in some hidden cauldron. And though I had no right to buckle — it was her grief, her sword slicing through *her* heart, even so — part of me unraveled as her thumb and forefinger reached out to lift one of her son's hairs from the shirt and place it deliberately into a leather pouch that hung around her neck. And then we sat there, two weathered stones, for a full hour. Two stone mothers allowing the unbearable to seep into our density, and willing ourselves to bear it. Eventually she put the shirt back into the bag, the bag into the closet — and we

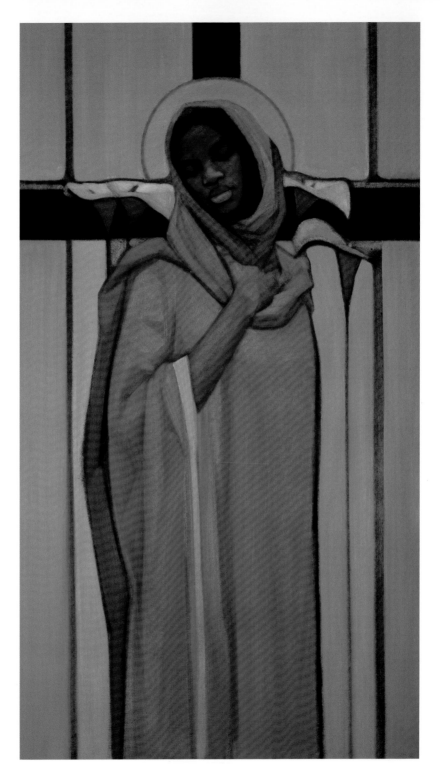

Mary, a Mother's Sorrow, oil on canvas (30 x 54 in)

each walked to our separate bedrooms to wrestle with the night in our own way. Sorrow, as it will, had come to wordlessly anoint another soul.

I am painfully aware that women throughout the world know the powerlessness and the plentitude of the breaking of the human heart. In the image of Mary, her hand across her heart, her eyes shut, yet her body almost majestic, I hear the words, *This is what it is to bear the details of your life, and not walk away.* I see in her stature the acceptance of what is; in her recesses, the force of light. And from an unseen realm, a powerful "yes" emerges as she faces the path she would never have imagined for herself. But any innocence is irrelevant. It has already been torn from her. What matters is her response, her yes. What matters is that she is encountering a woundedness in whose depths veils part. She is at the threshold of a radically different awareness that longs to make itself known. Bruised, yet yielded, a portrait of vulnerability, she is the very image of mourning. And yet at the same time she is held within the gentle embrace of great streams of inner knowledge. She is an ancient goddess — a complex, irrepressible symbol of woman.

In the slight turn of her head the human heart is completely exposed, nothing held back. Hers is a fierce openness to incarnation. I think of the words of Jan Frazier, "Eternity is here already. Truth is not handed to you. It's in you already, more real than bone."[1] I see in her bearing such depth — it seems the vault of inner life revealing its full compassion. If I were to give this Mary words I would have her say, *My roots are wide, my heart free.*

Standing calmly, unhurried, she endures this moment in time. But she is not captive to the sorrow. Calla lilies rise like flames from her coarse cloak, softening the black of the cross. Her wake spills beauty, not tears. Embedded in this momentary pain is the place of no pain. She is a fountain. She is life poured out. Imagine the power if we too were equally unafraid.

Pain has shattered beneath the gaze of her deep knowing. It announces itself briefly, then dissolves. It fractures, until all that's left is the glow of light.

This portrait is rendered in the form of Mary, and yet it is more truly the force of Spirit. It is Spirit reaching through the artist's hand in order to fill the majestic aura with a godlike glow. Still, beautiful as this alchemy is to behold, it's easier *not* to know it, not to be challenged by sorrow and its transformation into freedom. It's an immense responsibility.

What would I look like if I were as free? If I fell in love with what loves me and, looking back, allowed myself to know it in serene acquiescence?

The painting confronts us with the unbearable beauty of loss that has been transfigured by light, and our great answerability to the demand of that same transformation in our own lives.

When I take this painting and place it before me in the natural light, the particulars of Mary's face are difficult to distinguish. Her headscarf becomes a hollow that highlights the depth and darkness of her features and creates a compelling shadow. Unable to see her individual characteristics, the eye is drawn into the fullness of her deep, secret compliance with life. The painting is now Mary *and* every woman . . . every man . . . every person who labors to step beyond the surface of things into awareness of the subtle world of spirit that holds life in being. And it is in the dark, in the hidden shadows, in the inner sanctuary that this change

takes place. Words, again, from Jan Frazier, "Pain is a trapdoor... [that] opens under the terrible weight of full acceptance."[2] Pain, interestingly, revealing itself as a vehicle for love.

A final look. Her turning is so gentle. Nothing awkward, nothing affected.

Nothing sharp, nothing bitter or resentful. She is rounded like the deep bending of the reeds along the shore, the bowing of birds in flight, the dipping of supple bodies as they dance. She complies. Agrees. She is receptive to all that is. The pain may momentarily have caused her to stop, but there is a deeper reality and she knows it. She embodies it and *is* it. She makes it visible in her stature. There will be no "Why me?" from these lips. She may have uttered it initially, but she asks it no more. "Why me?" transposed itself as the shock rumbled through her body. All around her flowers grow in a soft halo. There is no necessity now other than breathing into the awareness that arises. There are larger places and this is what she has become.

Mary. Full of grace, full of sorrow. Full of heartbreak that has seen through the illusion into the full face of all that is holy. Holy Mary, full of grace.

I gaze upward, feeling the strength of the hand that is raised to her heart on my own breast.

Notes

1. Jan Frazier, *Words to Wake Up To,* CD, written and read by Jan Frazier, copyright © 2008.
2. Jan Frazier, *When Fear Falls Away* (San Francisco: Weiser Books, 2007), 177.

Dark Angel

Ann Patchett

his is a painting of the death of a child. It is a painting that tells us nothing of the child's life, but I will assume she was well cared for. Look at her braids, after all, the lines of her immaculate dress, the lily she holds in her hands. I take all of these as signs that she was loved. There is great tenderness shown to how she is arranged, the peach of her dress a warm undertone to the orange flower, the hint of blue inside her sleeves. One might think she was going to take part in a pageant or sing in a choir. There are no signs of illness. Her face is full and her cheeks flushed. There is color on her lips. This is a child who is so exactly on the precipice between life and death that at the moment of this painting it would be impossible to call her living or dead. Her last breath may still be on her lips. This girl is two fingers outside the grasp of those who love her, of those who cannot bear to let her go. The living have no place in this painting. Already they have fallen away, but still we can feel them standing beyond the edges of the frame. The suffering of those we'll never know, parents, sisters, brothers, friends, provides the energy that presses the child and her angel together into their incredible stillness. I imagine the family stretching, yearning toward the girl, and always falling short. Every minute they reach for her she is farther away.

This is not a painting about the child's afterlife, and clearly in the world of this painting there is an afterlife for her. Paintings of children's lives are often sentimental, full of fishing ponds and faithful dogs, but paintings that imagine some sort of eternity for children grow quickly mawkish: babies loll on beds of spun sugar, bursts of feathers growing from their shoulder blades. Warblers and bluebirds lay crowns of flowers in their hair. There is no place for the color black in those paintings. There are no black women, no black gowns, no black wings.

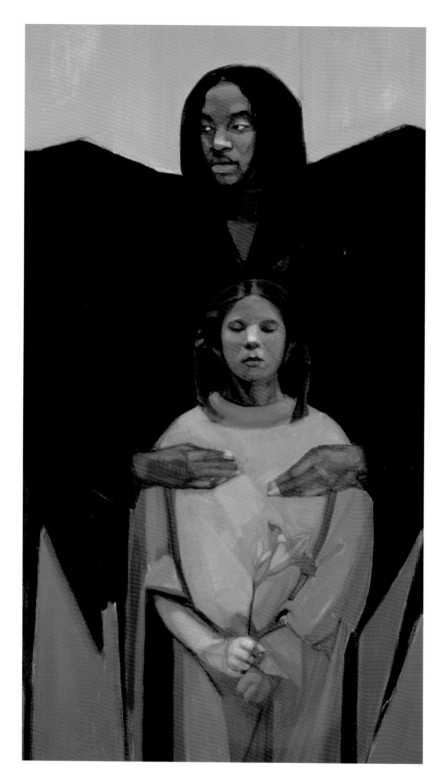

Dark Angel, oil on canvas (30 x 54 in)

We know this girl is going somewhere, but we're not given the ease of sentimentality to dull the edges of her enormous loss.

This then is neither a painting of an end nor the new beginning. It is a painting of immediate pain and the surrender of pain, the unmistakable present moment of death. "Look at her," the people around this child's coffin would say. "She looks just like she's sleeping." She looks like she is sleeping or sleepwalking, like she is brave or pretending to be brave. She looks like the holiness of her life is pooling inside her, tilting her chin slightly upward, and she looks like she is dead. All of those moments exist so closely together they become one. Is she holding the flower or did someone place it in her pale hands? Is she standing upright or stretched out? Is the angel holding her up or is the angel holding her still?

The Dark Angel is herself the canvas on which the child is painted. She is the backdrop, the underpinning, that slips beneath the girl and wraps around her. The expression on her face is that of a mother who holds her child back on the curb and watches the traffic. It is an expression that says, "Wait, in just a minute now we'll go." She is waiting it seems for the exact second of the child's death. She is waiting to stretch out her wings and lift her up. There is no struggle here. The angel did not capture this girl. She has merely come to bear her away. This, her tired expression seems to tell us, is the work of angels. Her hands are protective, open. I imagine those wings as extending endlessly beyond the edges of the canvas, architectural marvels of feather and bone that will eventually carry all of us off, one by one. For the dead, those wings are glory itself, but for the angel

they are the burden of her circumstance. The angel takes everything in stride, in fact, the comfort in this painting is the feeling from the angel, which reminds us that nothing extraordinary has happened. This child now; someone else later. The angel only waits for the right time. She will not take her too soon, nor will she make her wait alone. But for the child it is completely different. She is luminous, utterly focused inside herself. For her this moment is everything. It will be her only death.

Everything ends. Some endings are more tragic than others because they strike us as unfair. A child has been cheated if she dies so young. She should have grown up and fallen in love. She should have had children of her own and watched them grow old. She should have died once her life was finished instead of this moment when it had barely started. Her life should have been more than reading books and playing with friends and staring out the window at the snow. But endings are no more chosen than beginnings. The angel understands this. Her work is to scoop up this bundle of light at the very instant it is meant to fade, to wrap her inside those great, beating wings and carry her off to a world we can only imagine.

In the Garden of Blessings

Barbara Lundblad

e are often tempted by the literal, the verifiable, or by definite proof. Though we've been told that doubt is part of faith, we still prefer certainty. So we want to know: Are the women in this picture the two named in Matthew's Gospel? We check the written text to be sure it is Matthew who tells us of two women going to the tomb. Our memory hasn't failed us. Mary Magdalene is named along with the other Mary (we can't be sure which one).

Now we can ask the right questions, the ones that connect this picture with the words on the page. Why do both women have their eyes closed? Are they praying, or is it because they got up so early that morning long ago? The sun was barely up but they had been up for hours, waiting for the Sabbath to be over. Had they arranged to meet on a certain corner in Jerusalem? Perhaps they had stayed at a guest house, for we know that Jerusalem was not their home. They had come from Galilee. The text tells us that, but not much more. Somehow they found a place to buy burial spices in that early morning hour. They had no reason to bring them from home for they hadn't expected the week to end as it had.

Of course the text doesn't tell us such things, but we can allow ourselves a bit of imagining as long as we're careful not to stray too far from what is written down. They waited until the sun had risen, when it was safe for women to walk the city streets. Light was beginning to color in the gray shadows in that morning time when birds sing in full chorus. But these women weren't listening to the music as they walked toward the gravesite. They knew exactly where it was, for they had been there when Jesus was buried. Both of them were there, along with Joseph of Arimathea. Strange, isn't it? Joseph had adopted Jesus as a baby wrapped in swaddling clothes. Now a different Joseph wrapped his lifeless body in linen cloths and laid him in the tomb.

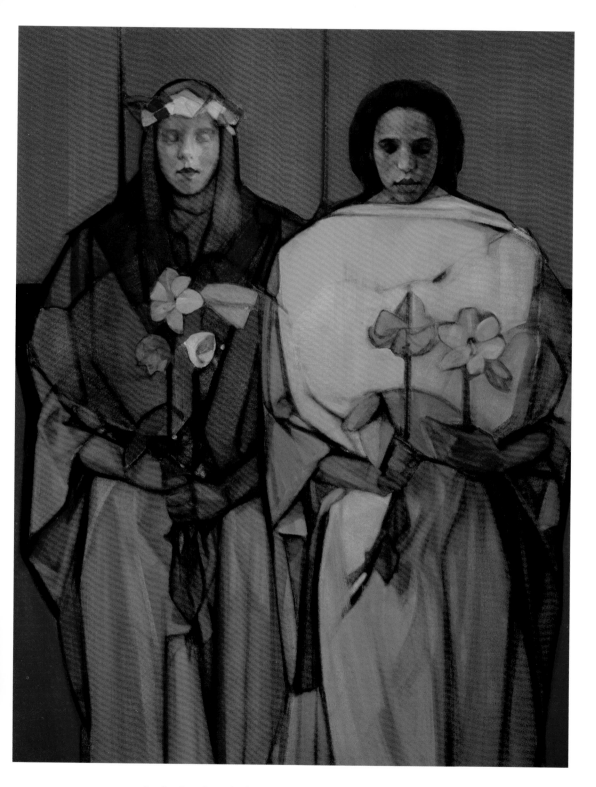

In the Garden of Blessings, oil on canvas (42 x 54 in)

What do these two women with eyes closed want to tell us? Are they remembering how Jesus changed their lives or trying to block out the pain? Looking at the picture, we can't be sure if the women are going toward the cemetery or returning home. Are they bringing flowers for the grave or bearing Easter lilies to surround the altar? The text tells us only this: they were saying to one another, "Who will roll away the stone for us?" Maybe they were looking down as they are in the picture, longing to be distracted from what they didn't want to see. By the time they looked up they were already at the tomb and saw that the stone had been rolled back. It was as large as they had remembered.

No, that is a different story. All of that happens in Mark — the question about the stone and the discovery that the stone was rolled away. But this painting cannot be Mark for there are three women in that story — two Marys and Salome. The picture doesn't fit the text. We want everything to fit together. We want certainty, not confusion. But if we return to Matthew's story an earthquake shakes the ground and an angel sits on the fallen stone. If we go to Luke three women are named along with several others.

No matter which text we choose, the women have no need for burial spices. Jesus' body isn't there. Mark says the women were startled by a young man in a white robe; the others say it was an angel. No matter which is accurate, the message is the same: "You are looking for Jesus who was crucified. He is not here. He has been raised." Whether there were two or three or thirty women, they were scared to death. After all, they had never read an Easter Gospel. They only knew they had seen Jesus die. They had seen his lifeless body wrapped in linen and laid to rest, the stone rolled in place. They knew what they had seen. They had come to anoint his body as they always did at the time of death. They knew what to do about death, but they did not know what to do about this. Do we know what to do?

The artist is not bound by our rules. She will not be limited by the literal. She does not demand certainty or deny doubt. Look again. Do you see the stone? The dark-skinned woman seems to be carrying a stone. At first glance we thought it was her robe, gray and strangely large. But now we see that she bears the stone. Is that how it always is? We carry the stone within us — the stone of impossibility and despair, still wondering, "Who will roll away the stone?" That is not an old question. We know the stone's weight. Death is all there is, the stone insists.

Despair pushes hope underground. There are no answers that roll the stone away forever. The women are praying for us and with us: remove the stone that seals us in impossibilities.

The artist isn't bound by our rules or by the words on the page. Perhaps all the women of the Gospels are gathered up in these two figures, one dark-skinned, the other fair. Lay the picture on the floor and look down from above. We are at a funeral — two women lying side by side, lilies placed in their hands by loved ones. We have come to mourn for them and give thanks for their lives. These women are our ancestors in the faith, the first to preach the resurrection Gospel even though others scoffed at their breathless testimony.

Lift the picture up again. Now we see that the risen Christ has become part of them. One woman wears a braided crown, wrapped around her head like ragged thorns. Look closely at her hands. Are her knuckles bleeding? When we turn to her companion we can see leaves pushing through the lifeless stone. "Unless a grain of wheat falls into the earth and dies, it remains alone." No longer alone, the seed has taken root and come to life. Jesus is no longer in the tomb of long ago or bound within the text. Jesus is in these women. They have become the Body of Christ.

Look again. We can't be completely certain if both figures are women. The artist has given us another painting, *Jesus of the People.* Remembering that painting, we may begin to see Jesus' face behind the stone: dark skin, chiseled mouth, broad nose, black hair. In that painting is Jesus a man or a woman? We argue with the artist: "Jesus doesn't look like that." Our protests come from the certainty of our own skin or our own gender. If we look beyond what we know, we can see Jesus and Mary Magdalene. They carry lilies from the garden in their hands. Now the painting has carried us into John's Gospel. "Do not hold me," Jesus said to Mary. "That is not how you will know me from now on. I will be with you in some other way. Not by fact of birth or death, nor by proof of resurrection. But I will be with you. I will be with you in a word spoken, a story told and retold — from an empty tomb, a cleft in the rock from which you may see a glimpse of God. Do not hold me, but go tell the others: I have seen the Lord."

All of this is in the window, leaded glass as red as blood, red as the sun at early dawn. Are these two standing in front of the window or are they in the window, their faces and garments etched by leaded panes? Perhaps we are still trying to

discern if the painting is Matthew's story or some other. But we really don't need to know. The texts, too, are windows, refracting light at different angles. Without each story the picture would be incomplete.

We can keep staring at the painting, asking our questions or throwing up our hands in confusion. Yet we cannot remain spectators looking on. The artist invites us into the window where we dare to carry resurrection lilies from the grave even when the stone remains. The doubts never go away completely, yet we have let the burial spices drop from our hands. Jesus is not dead. Jesus is not back there or up there or bound to history. Suddenly, a poet stands beside us, tugging at our sleeve. She sees Jesus is in the women in the window and she sees Jesus in us. She turns to us and says, look:

> . . . the world is turning
> in the body of Jesus and
> the future is possible[1]

Notes

1. Lucille Clifton, excerpt from "spring song," from *Good Woman: Poems and a Memoir 1969–1980*. Copyright © 1987 by Lucille Clifton. Reprinted with the permission of BOA Editions, Ltd., www.boaeditions.org.

Stillness

Mary Jo Leddy

he two women pause and gather their lives up in this single moment. They do not look at each other. They close their eyes and look within, behind, and ahead. They stand still, between all that has been and all that shall be. This is the rarest of moments in the rush that picks a life up and pushes it forward.

It is the time of ingathering — all those loose ends, the dropped threads of their lives, the unraveling of relationships, the frayed edges of meaning. In the stillness the thin thread of life lengthens, slightly.

It is the time when the women, perhaps refugee women, have come to the edge of all that they have known, all that they have been. They gather up their lives, gather up who they have become and prepare for the walk into the unknown. Will they find a place to land? Will they be given wings?

It is the time between countries, between lives, between people.

The border of stillness.

Before this moment there was the loud crying task of giving life, the buzz of bearing with, of bringing forth the little innocents. There were the songs for the small ones who slept and there was the yelling and screaming, the warnings of danger just around the corner. Before this moment, there was the long sorrow that had to be kept quiet and hidden.

Before this moment, they carried the weight of words and regulations, the crush of cruelty and barking orders that hounded them from place to place.

Life slipped through their fingers as they tried to hang on, to hold on. They are weary from moving without ever really arriving.

No one has ever asked them to stay.

Home is never, never land.

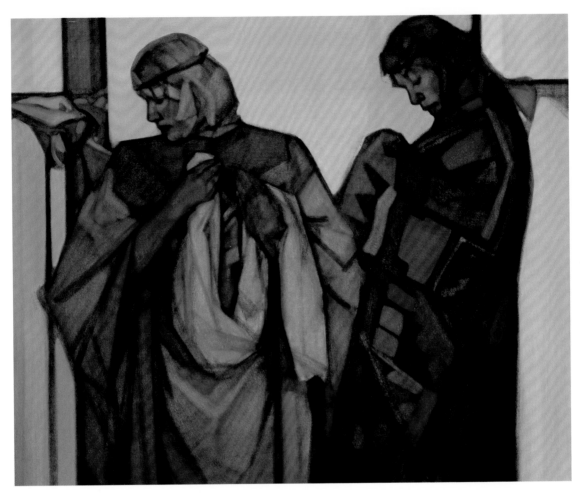

Stillness, oil on canvas (54 x 44 in)

These are women forever on the move. The powers tell them: Move along, pull up your life and just keep going. Do not stop. Not here and not now.

These two women have kept moving to keep alive. There are many other women who keep moving along the fast lane in order to feel alive. For each and for all, stillness is the moment of freedom.

Stillness is the border between who you were and someone you have yet to meet.

On the other side of stillness is the vast space of uncertainty. Whom will I meet? Will they welcome me or will they walk away? Will they tell me to move on?

The still small voices whisper to the woman. "Or maybe someone will look me in the face, and will tell me I am beautiful beyond all words. Perhaps someone will tell me that my children will be treasured by the nation. Perhaps someone will look upon us and see that we are good."

Still.

The women know the pieces of their lives are being gathered up. They are still here. They are still ready to walk toward the borders that nations have constructed between the insiders and outsiders. These are the borders where people wait and wait to the sound of Muzak and the shuffling of papers. There is no stillness in this waiting.

The two women recognize each other in the lineup at the border. Are you still here?

Yes, I'm still here.

The One Sent: Mary Magdalene with Jesus, the Christ

Susan Calef

I painted Mary Magdalene and Christ seated side by side as visionaries and spiritual teachers with their hands open in the universal gesture of prayer — gifts offered and received — as icons of the sacred. Jesus, the Christ, sent to live among us as the Word Made Flesh, and Mary Magdalene, the first one sent to proclaim the resurrection, are models for the community of disciple-companions sent "to the ends of the earth" to tell and become the Good News for all. — Janet McKenzie

he One Sent: Mary Magdalene with Jesus, the Christ. The very words recall the climactic scene of the Gospel of John, that of Mary Magdalene's dawn encounter with the Secret Gardener. "Mary!...Go, tell my brothers and sisters..." (John 20:16–17). For centuries artists have rendered the scene familiar: the Risen Christ stands above and Mary kneels below, her outstretched hand reaching for him as he rebuffs her. "Do not cling to me," the image speaks.

In striking contrast, *The One Sent* images not a Gospel scene but a vision, a vision of the Wisdom-Word that dwells in the deep of John's Gospel. From the opening words "In the beginning" to its climactic return to a garden, the fourth Gospel evokes a new creation, worked and signed upon the world by the Word-made-flesh. For those eyed to see by John's Gospel-telling, the image set before us speaks, not "Do not cling to me," but "Come and see."

> In the new beginning...side by side:
> the Christ, not above but beside;
> Mary Magdalene, not beneath but beside;

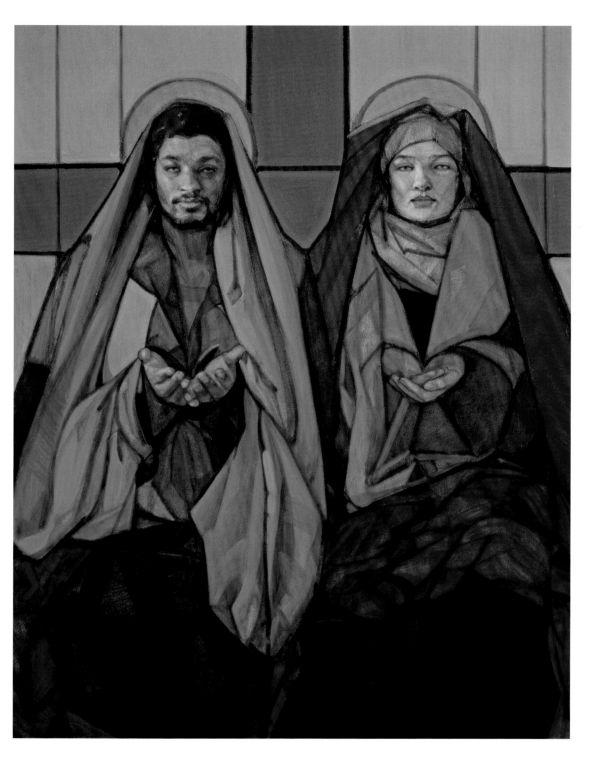

The One Sent: Mary Magdalene with Jesus, the Christ, oil on canvas (42 x 54 in)

Collection of Barbara Marian, Harvard, Illinois

shoulder to shoulder, two-gethered by the cross
rising behind, to one them.
No more the curse "he shall rule over you,"
but blessing,
"I do not call you servants, but friends,
for I share with you everything I receive from my Father."
I AM for you Friend. You ARE, We ARE . . . Friends.

Robed in a "fullness of grace that is truth,"
the WeOne is all hands and eyes and face for us.
From beyond within, hands emptied full extend,
betweening heaven to earth, self to other.
Palms cupped up and open, receive.
"The Father loves the Son, and has given all things into his hands . . . "
give . . .
"the words that you gave to me I have given to them . . . "
receive . . .
"From his fullness we have all received, grace upon grace,"
the spiriting rhythm that breathes the world to life.
Through chaliced hands brimming with Divinity
pours the good wine that weds us One . . .
family, fashioned by Godgrace abounding.
"To all who received . . . he gave power to become children of God."
By offertory for Communion . . . I AM Son, You ARE Daughter;
We ARE Brothered, Sistered, One to Another.
No one enters the Kindom of God unless born of water and Spirit.

The Word-made-flesh quests, "What do you seek?"
"Where do you abide?" the wise request that follows.
"Come and see. . . . "
Eyes transfixed, the Vision holds them still:
In the beginning was the Word, and the Word was with God,
and the Word was God.
In the beginning was . . . the Relation.
No one sees the realm of God unless born from above.

Whoever sees me sees the One who sent me.
Soon the world will no longer see me, but you see me;
because I live, you also live.
You will see greater things than this:
from the wound water breaks . . . and blood, to birth a world new.

Seated, utterly still, the One Sent abides . . . in the Relation.
I am in my Father, you in me, and I in you.
She who abides in me and I in her will bear much fruit.
If you abide in my Word you will know the truth,
and the truth will make you free.
God is Love, and those who abide in Love abide in God, and God in them.
In the Love that crossed the world to God . . . the One Sent abides.

Jesus-flesh, eastered exquisite by impassioned color
full Christ-Body becomes . . .
sexed, colored, cultured new:
There is no longer Jew or Greek,
no longer slave or free, male or female;
for all are one in Christ Jesus.
There is now . . . the Different One.
Christ-Body faces us OneAnother:
black, white, yellow, red, male, female.
The glory you have given me I have given them,
so that they may be one, as we are one.
Crossing difference, each for other,
I AM . . . We ARE . . . Body of Christ,
gloried God the Different One.

In the garden dark with death, the Word quests AnOtherOne:
"Woman, whom do you seek . . . ?
"Where have you laid him?" her wise request.
Tombed darkness opens
that Light might dawn the Truth by name:
"Mary!" "Rabbouni!"

I ... Thou ... the Relation ...
a Truth so wide and deep that into its dark
one must surely plunge, for lifting up
to rise ... into fleshly glory,
Life luminous in Love.
From unto the Relation
"Go to my brothers and sisters,
and say, 'I am going to my Home and your Home, to my God and your God.'"

At the crossing, the One Sent sees, believes, knows, abides in the Relation.
Mary Magdalene, One Sent by AnOtherSent,
abides ... with Christ ... in God:
Two but One, One but Two, in Three.
Two-gethered One in Mystery: ...
as it was in the beginning, is now, and ever shall be ...
We ARE Imago Dei.
In the beginning was the Relation.
The Word was with God, and the Word was God.
In the beginning God created humankind,
in the image of God, male and female God created them.
The Word made Image dwells among us!
Come and you will see.

The Inspiration of St. Monica

Katie Geneva Cannon

lmost all we know about St. Monica, the mother of St. Augustine, is found in Augustine's *Confessions* (Book IX). Born to Christian parents in North Africa, around 333, Monica was married to Patricius, a pagan Roman official who was a womanizer with a violent temper. Nonetheless, Monica remained a model of patience. Due primarily to her prayers and her strong character, Patricius eventually became a Christian and was baptized shortly before he died. Monica and Patricius had three children, and Augustine, the eldest, a wayward youth, seemed to be following in his father's footsteps. However, Monica was unceasing in using her strength and prayers to lead her son to God.

Unbidden, Monica followed Augustine from Carthage to Rome and then on to Milan, where she came to know Ambrose, the bishop of Milan. Monica's prayers were finally answered as she became mentor as well as mother to her son. They were able to spend six peaceful months together in Milan. After Augustine's baptism by Anselm, mother and son began their journey back to Africa. Unfortunately Monica became ill and died at Ostia, a village near Rome. Bereft, Augustine wrote, "This was the mother, now dead and hidden awhile from my sight, who had wept over me for many years so that I might live in your sight."[1]

Janet McKenzie's Monica portrays an African woman of great dignity and strength. Her strong upraised hands meet each other in prayer. Indeed, the viewer's eye seems to be drawn to them. Her very demeanor exudes steadfastness and patience. This is not a woman who will give up. In describing St. Monica, Janet McKenzie wrote:

> For me, St. Monica was so much more than a mother caring for her beautiful baby. She was a woman who saw her adult son as he was — a womanizer,

107

The Inspiration of Saint Monica, oil on canvas (36 x 48 in)

a "player" in today's jargon, and a man greatly out of touch with his soul and with God. She longed to care for him and his spiritual well-being. At that time, although it was dangerous for a woman to travel alone, she courageously followed Augustine far and wide, believing fervently with unshakeable faith that she could bring her child to God. Her lifelong sense of responsibility to her child and her understanding of commitment drew me to her. She inspired my interpretation — steadfast and grounded in belief, iconic and darkly beautiful, and always in prayer.

It is easy for African American women to connect with Augustine's mother. Like St. Monica, whose habit of prayer was a literal wrestling with God for the soul of her son, black women have wrestled throughout generations not only for the souls, but also for the bodies and minds of their children. African American women can also resonate with St. Monica's inner strength, her determination and fortitude, and in Monica's faithful witness and prayers for her children and her husband they can see a life lived with integrity, even in the most difficult situations.

During two and a half centuries of slavery, followed by another century of legalized racial segregation in the United States, African American women teachers and mentors have shared a common bond with St. Monica. By the end of the eighteenth century, relatively small but significant numbers of African American women became formal educators and informal mentors to whoever needed their help. Working day and night and limited by rigid job restrictions and deep divisions of inequalities, enslaved black women began to teach, in the belief that education made members of the African Diaspora less susceptible to the indignities and proscriptions of racial prejudice and oppression. Black children were taught from the outset that the goal of their education was to form them for a life of service to uplift others.

The vast majority of African Americans experienced incredible suffering after the Civil War. Although Emancipation removed the legal and political slave status from approximately four million black people, the general patterns of white supremacy continued. The chief cornerstone that morally justified slavery — the supposed inherent inferiority of African people — became even more passionately entrenched after the Civil War, and the dynamics of power remained much as they had been before the war.

With justice denied, hopes continually thwarted, and dreams often shattered, learning to read, write, and do arithmetic in overcrowded one-room schools took on even greater significance. Despite a scarcity of funds, multiple obstacles, deplorable learning environments, and few textbooks or supplies, teacher after teacher said to students in run-down, dilapidated Jim Crow buildings, "I will give you the best I got and I want you to be better."

Black women educators also attended Sunday services at local churches, where they taught worshiping congregations. They prayed and preached, reviving ancestral memories and creating new forms of worship with music that drew from the deep wells of life in Africa and slavery. Throughout the nineteenth century, trained Sunday school teachers mentored black congregants to become advocates for justice and to critique religious traditions that had been embedded in centuries-old, unwritten commandments of institutionalized slavery.

Black women also served as mentors outside the church. They defied demeaning racial stereotypes, such as those of the characters enshrined in Harriet Beecher

Stowe's epic *Uncle Tom's Cabin; or, Life among the Lowly*. When asked where she was from, Topsy, the young, faceless, depraved outcast, the symbol of ascension from deathly chaos, responded, "I just popped up!" Such ahistorical people do not exist. So black educators taught the people their rich history.

During the Reconstruction, African Americans were still not allowed to purchase land. Every year white landowners and merchants provided African American sharecroppers with loans at high rates of interest to purchase seeds, tools, food, fuel, and other necessities. At the end of the harvest season, the sharecroppers were compelled to turn over a large share — or perhaps all — of their crop to pay back their high-interest loans. Tottering between dependency and despair, African Americans found themselves legally bound to labor to pay often trumped-up charges that accrued from year to year, creating involuntary slavery for an overwhelming majority of black families. Fortunately the teachers and mentors, trusted counselors, were able to decipher these exploitive schemes, which somewhat eased the struggle of daily life.

In the twentieth century black women developed many social service leagues and local aid societies. As tens of thousands of African Americans moved from south to north and from rural to urban areas seeking relief from stifling circumstances, black teachers sponsored fundraising fairs, concerts, and all forms of social activities to enable the black church to serve as a bulwark against laws and systems that treated African Americans as nonentities. Women organized clinics, sewing classes, mothers' clubs, and community centers. Teachers encouraged students, young and old alike, to stay open-minded and to expand their horizons between the familiar and the foreign, between bygone years and the present time.

Black women educators were also active in the suffrage movement. In August 1920, when women's suffrage was finally ratified, thousands of African American women began to register voters. As literacy tests, civil service examinations, proof of birth, and a myriad of other devices were deviously used to restrict the voting rights of black women, they persisted, confident of the rightness of their position.

In addition to teaching the required courses of study and providing vocational training, educators continued to disentangle culturally sensitive issues. They contrasted the Christian doctrines preached in church with the violent rape and brutal lynching of vulnerable black people, violence that was neither accidental

nor arbitrary. Using keen analysis and powerful voices, African American teachers exposed the ugly underside of life, the unjustifiable diminution of black humanity.

Mentors also uncovered the myriad ways in which black people were assets to civilization, working to instill in all black Christians an understanding of the potential of each human being. These teachers, mostly trained in church-sponsored historically black colleges and universities, encouraged God-fearing women, men, and children to relate rightly to the God of the whole world and all "livingkind" in it.

While the circumstances of St. Monica's life as teacher and mentor and those of contemporary black women have different points of origin, her moral agency resonates, explicitly and implicitly, with the long-held belief of African American women in communal deliverance. Even today St. Monica's ability to hold on to life against formidable oppression is an incentive to continually chip away at oppressive structures, to stand strong, to live in faith and prayer, to celebrate what can be, and to raise a prophetic voice, knowing that all is possible. Monica's capacity for prayer reminds me of the words of Elizabeth, born a slave in 1766.

> I had none in the world to look to but God, I betook myself to prayer, and in every lonely place I found an altar. I mourned sore like a dove and chattered forth my sorrow, moaning in the corners of the field, and under the fences.[2]

Notes

1. Robert Ellsberg, *All Saints* (New York: Crossroad, 1997), 370.
2. *Can I Get a Witness? Prophetic Religious Voices of African American Women: An Anthology,* ed. Marcia Y. Riggs (Maryknoll, N.Y.: Orbis, 1997), 3.

St. Josephine Bakhita

M. Shawn Copeland

n October 1, 2000, John Paul II canonized Josephine Bakhita, a Sudanese woman, freed slave, Canossian Daughter of Charity, "flower of the African desert," "patron of Sudan," and, by her own self-designation, "a daughter of God." Janet McKenzie's oil painting of Bakhita suggests a sentry, a woman composed, fiercely and lovingly guarding the children of her native Darfur. While her biographer focuses on Bakhita's practice of the virtues of humility and meekness, McKenzie depicts courage, fortitude, and hope — virtues Bakhita surely needed throughout her life.

What we know of Josephine Bakhita's early life comes from the story that she dictated in 1910 at the direction of her religious superiors to relate "some events of her time in slavery." This document, held in the Canossian Archives in Rome, may well be the only extant slave narrative by a Roman Catholic.

Bakhita was born in 1869 a member of the Dagiu' people in Darfur, western Sudan. She described her family — father, mother, three brothers, and three sisters — as happy, reasonably prosperous, and well respected in their village of Olgossa. Her father owned sizable herds of cattle and sheep as well as fields that were cultivated by hired help. The Dagiu' people are reputed to be peaceful and hardworking, but then, as now, they and all the indigenous peoples of Sudan faced precarious circumstances.

The medieval Arab geographers charted Darfur as part of the Sahel or *bilad al-Sudan* (the land of the blacks). Today the people of the region share a complex heritage derived from commercial, social, cultural, and religious encounters among tribes of Africans and Arabs. To outsiders all the people of Darfur appear racially identical, but ethnic distinctions set them apart from one another and stoke enmities rooted in ancient rivalries. Little is known with certainty about the peoples of Sudan until the seventeenth-century emergence of Suleiman and his quest for

113

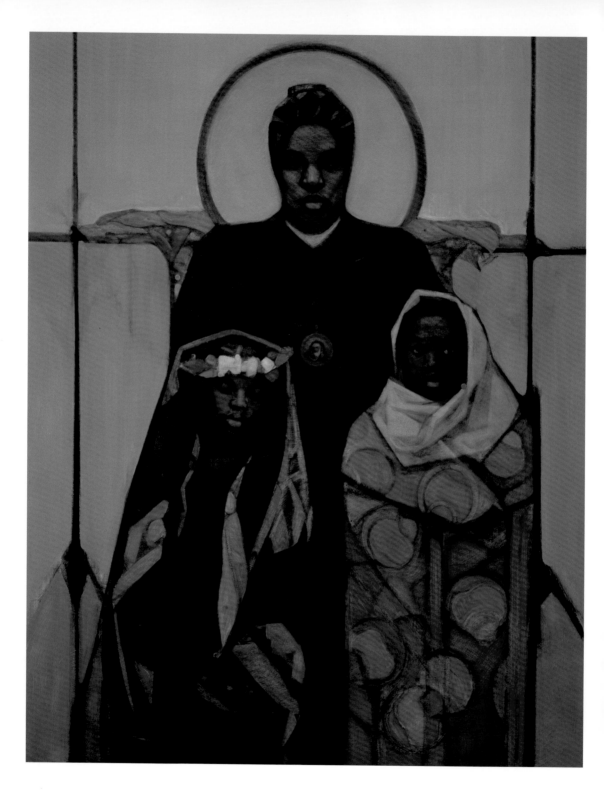

St. Josephine Bakhita, oil on canvas (42 x 54 in)

territorial expansion and trade, especially in ivory and black slaves. But it is likely that well before the sixteenth century the peoples of western Sudan had been prey to aggressive slave-raiding by Egyptian, northern Sudanese, and Arab traders.

Although Christianity had a stake in Roman North Africa, Egypt, and Ethiopia as early as the first century C.E., from the seventh century forward it was challenged by the vigorous spread of Islam. The Qur'an holds that freedom is the natural condition of human beings, but does not condone slavery outright. Rather, Islam's sacred scripture attempts to ameliorate its conditions, even promote manumission. The enslaved were entitled to adequate food, clothing, and medical attention and treated with dignity and kindness; they were not to be beaten or abused and were to be cared for in old age. But it should come as no surprise that Muslim slaveholders, like their Christian counterparts, violated these injunctions. Muslims were not to be enslaved, but an enslaved person's conversion to Islam did not ensure freedom.

Young children and women were specific targets of trans-Saharan slave-raiding and trade. Young girls and women were sold for domestic use (for agriculture, cleaning, cooking, cloth-weaving), concubinage, and often both, as male slaveholders could claim the right to use them sexually. Some young boys were pressed into the military, but many were castrated for service in harems or in mosques.

When Bakhita was five or six years of age, slave raiders kidnapped her eldest sister. Three years later, while Bakhita was strolling outside the village with a friend, two Arabs used deception to separate her from her companion and then kidnap her. Threats and rough treatment so traumatized the little girl that she was unable to shout for help and could not speak her own name when questioned. With mocking irony, the men named her "Bakhita" (fortunate or lucky one), a common appellation for female slaves.

After a day's march, the men locked Bakhita in a dark hut for more than a month and then sold her to a trader. Between 1876 and 1882, Bakhita was sold to three different masters, including a general in the Turkish army. The last slaveholder, albeit benign, was the Italian vice consul Callisto Legnani. During the two years that Bakhita was held in the vice consul's household, the political situation in Darfur deteriorated as the people rebelled against the "corrupt, increasingly arbitrary" rule of Egypt.

Finally in 1881 Muhammad Ahmad Abdallah declared himself to be the Mahdi, "the divinely guided one" of Sunni Islamic belief, "who would restore justice, unite Muslims, and signal the end of the world." The impending arrival of the Mahdi and his army forced Vice Consul Legnani to leave Khartoum. Bakhita first requested and then insisted that she be allowed to accompany him to Italy, hoping for a new life, but upon their arrival in Genoa, Legnani gave her as a gift to a friend, Venetian merchant Augusto Michieli.

Michieli and his wife, Maria Turina Michieli, took Bakhita to their hotel in Zianigo in northeast Italy. The adolescent girl adapted to her duties and took on the care of the Michieli's daughter, Alice. A few years later, Mr. Michieli returned to the Red Sea port city of Suakin in Sudan, where Venetian merchants conducted business. There Michieli purchased a luxury hotel and planned to relocate his family and Bakhita. Mrs. Michieli traveled to Suakin in order to clarify the terms of sale of their property in Zianigo. Prior to her departure, she directed Illuminato Checchini, the manager of their hotel, to place Alice and Bakhita with the Institute for Catechumens run by the Canossian Sisters.

Bakhita found a true friend in Checchini. Once, while in his home, she discovered a crucifix; gazing at it intently she wondered: "Who are you? Why have they put you on the cross?" The manager told her about Jesus Christ, the son of God. While her poor command of Venetian (Italian) and her lack of religious background may have hindered the depth of Bakhita's understanding, she knew the pain of the lash, of beatings, of abuse. She too was a person of sorrow, despised, and rejected (*Bakhita: From Slavery to Sanctity*, 43).

Checchini gave Bakhita a silver crucifix. "As he gave it to me," Bakhita said, "he kissed it with devotion. I looked at it almost secretly, was filled with a mysterious force and felt something inside me that I could not understand" (*Bakhita: A Song of Freedom*, 45). Almost immediately, Bakhita expressed her desire to become a Christian. For nine months, she was nurtured and enjoyed the solace of the catechumenate where she "came to know the God whom I had felt in my heart since I was a child without knowing who he was" (46).

But this time of joy and consolation was interrupted with the arrival of Mrs. Michieli, who demanded the return of her slave Bakhita to accompany her to Sudan. The young woman refused to comply, thereby provoking a legal and

religious crisis. For her the Institute had become a physical and emotional sanctuary and also a place of prayer and contemplation. With the legal assurance that on Italian soil she was a free person, Bakhita recalls that she fixed her eyes on a crucifix on the wall in front of her and declared, "I can't leave this place because I don't want to lose God" (48). On January 9, 1890, Bakhita was baptized Josephine Margaret Maria Bakhita, received communion, and was confirmed.

Six years later, at the age of thirty, after three years of religious formation, Josephine Bakhita made her profession of vows as a member of the Canossian Daughters of Charity. She lived and worked at the Institute until 1902, when she was transferred to a Canossian house in Schio, where she carried out various domestic duties.

Her biographer comments that people from all walks of life and of all ages were attracted to her goodness. Through prayer, she devoted herself to the welfare of her African brothers and sisters as well as to all who crossed her path. Throughout her adult life she demonstrated only sympathy and forgiveness toward her former captors and oppressors and prayed for them continually.

During the World War II, Schio endured heavy bombing, but the people suffered no casualties. The townspeople of Schio admired Bakhita, respected her, relied on her listening ear, advice, and counsel, indeed, her very presence. They believed that her prayers and intercession protected them from harm. Repeatedly Bakhita urged, "Those who trust in God, treat God as God" (58).

In 1943, after fifty years in religious life, Bakhita's health began to decline; she was diagnosed with arthritis, asthma, and bronchitis. As her body weakened and twisted with pain, her strength diminished and even walking with a cane grew difficult. Bakhita began to use a wheelchair, and when she could no longer use it alone, she asked to be pushed to the chapel. There she spent hours in prayer "look[ing] from the Tabernacle to the Crucifix." It seems that perhaps Bakhita gave herself over to the awe she experienced as a child. She tells us that from an early age she was drawn to the beauty and mystery of nature — the rising and setting of the sun, the bright night stars, flowers and plants of all kinds. Often she asked herself, "Oh who is the Master of all these beautiful things? How I would like to meet him and pay him homage!" (14).

Josephine Bakhita contracted severe pneumonia in February of 1947. When one of the sisters inquired about her condition, Bakhita replied:

I'm going slowly, slowly towards eternity. . . . I'm going with two suitcases: one contains my sins and the other, which is much heavier, contains the infinite merits of Jesus Christ. When I appear before the judgment seat of God, I will cover my ugly suitcase with the merits of Jesus and Our Lady and I will say to our Eternal Father: "Now judge what you see." Oh, I'm sure I won't be sent away! Then I'll turn towards St. Peter and I'll say to him: "Close the door because I'm staying here." (61–63)

Josephine Bakhita died on the evening of Saturday, February 8, 1947.

Despite an obscure life, Josephine Bakhita has captured the imagination of millions. She is venerated as the patron of Sudan, and her story evokes the ongoing suffering of women and children in contemporary Darfur. The people of Schio claim her as their own and African American Catholics have embraced her. Her life and faith have inspired a docu-drama, *Two Suitcases: The Story of St. Josephine Bakhita,* as well as a musical, *Bakhita.*

During her final illness, she assured the sisters who stood around her bed: "Don't be sad, I'll still be with you. If the Lord allows me to, I'll send many graces from heaven for the salvation of souls" (24). Janet McKenzie's *Bakhita* radiates the courage and confidence of that promise.

Sources

Dagnino, Sr. Maria Luisa. *Bakhita: From Slavery to Sanctity.* Nairobi: Paulines Publications Africa, 1998.
———. *Bakhita: A Song of Freedom.* Verona: Figlie della Carità Canossiane, 2000. This account is drawn from the Canossian Archives in Rome.
Daly, M. W. *Darfur's Sorrow: A History of Destruction and Genocide.* Cambridge: Cambridge University Press, 2007.
Gomez, Michael A. *Reversing Sail: A History of the African Diaspora.* Cambridge: Cambridge University Press, 2005.
Two Suitcases: The Story of St. Josephine Bakhita (docu-drama) is available on DVD from Ignatius Press.
Bakhita (musical). See www.bakhitamusical.freeservers.com/home.htm.

Our Lady of Guadalupe

Jeanette Rodriguez

very Catholic schoolgirl is brought before the presence of at least one Marian image. As the daughter of an Ecuadorian mother and father who migrated to the United States in the 1950s, I grew up with the image of La Madre Dolorosa, a suffering Mary portrayed as a mother with seven swords piercing her heart. As a young, independent teenager growing up as a New York Latina, I rejected the image. I had grown tired of seeing the suffering of so many mothers, daughters, and sisters. La Madre Dolorosa represented both the suffering and grace found in suffering even in the midst of war, poverty, drugs, and crime that seemed to be passively endured in the name of God and unredemptive.

I first learned of Our Lady of Guadalupe in the early 1980s when, as a student at the Graduate Theological Union at Berkeley, I began working with farm workers in Salinas. They had a great devotion to Mary that exuded profound intimacy, trust, and love. It was undeniable that there was an encounter, a presence, and a living relationship between them and La Virgen de Guadalupe. I am grateful to this faith-filled community for sharing with me their understanding of this complex image.

In the sixteenth century the history of Mexico was decisively altered when Hernán Cortés conquered the Aztecs and asked the king of Spain to send Franciscans to evangelize the "New Spain." When the Franciscans arrived in 1521, their work of evangelization was done in a climate of violent oppression. The indigenous people understood the conquest as a sign that their gods had been overthrown or had abandoned them. For them, all was lost. Then Our Lady of Guadalupe, the maternal face of God, the beloved mother of God, arrived to console this suffering people.

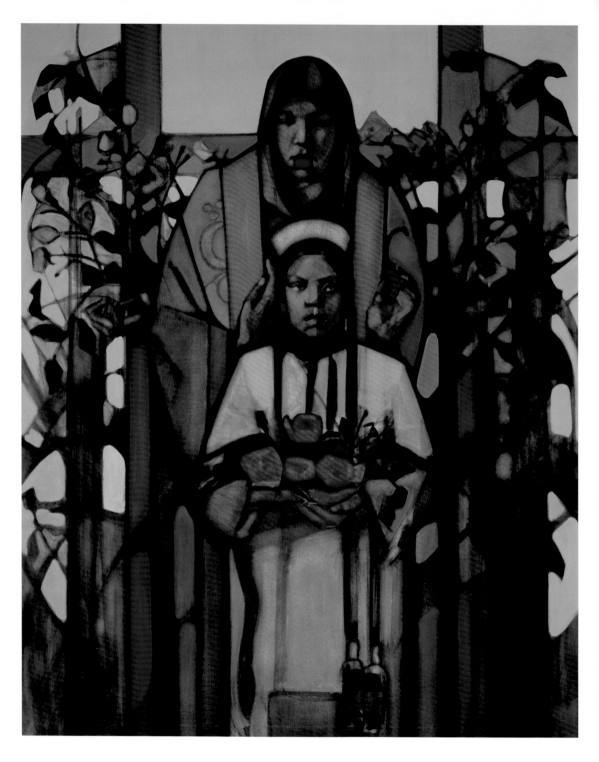

Our Lady of Guadalupe, oil on canvas (42 x 54 in)

Collection of Patti and Richard Gilliam, Santa Fe, New Mexico

The story of Juan Diego's encounter with Guadalupe at Mount Tepeyac on December 9, 1531, quickly spread among the people and was later transcribed from their oral language of Nahuatl in the epic *Nican Mopohua.*

On his way to church one morning, Juan Diego, a fifty-two-year-old indigenous convert heard beautiful music and wondered, "Have I gone into paradise? Can I be hearing what I am hearing?" He looked to the east, the home of the sun and symbol of God, and saw a woman of nobility standing before him. Clothed with the radiance of the sun, she addressed him with the diminutive form, "Juan Dieguito," conveying maternal love and reverence: "Know and be assured, the smallest of my children, that I am the ever Virgin Mary, Mother of the true God, for whom one lives, the creator on which all depends, Lord of the heavens and the earth." She then told Juan Diego that she wanted a *casita* to be built for her, a place where she could bestow her love, compassion, strength, and protection on all who called upon her and trusted her.

Faithfully following her mandate, Juan Diego went to the bishop in Mexico City, only to be told to come back later. He returned to Guadalupe and despondently told her that he was the wrong messenger, that she should send someone "of greater importance, someone who is known, respected, and esteemed."

The Virgin absolutely refused to choose another and reaffirmed her desire that Juan Diego be her messenger, although she had "many servants and messengers" from whom to choose. With this reassurance and empowerment Juan Diego returned to the bishop. The bishop stated that he could not build a temple on an Indian's word alone and sent Juan Diego back to ask the Virgin for a sign.

When Juan Diego returned to his home, his beloved uncle, Juan Bernardino, who had fallen ill, asked Juan to go to Mexico City to bring back a priest to administer the last rites. Juan Diego was caught in a dilemma! Should he fulfill his uncle's request or should he meet the Lady in order to receive a sign for the bishop? Juan Diego chose the mission for his uncle.

On his way back to Mexico City, Juan Diego took a different route so as not to "disappoint the Lady." However, while walking, he heard the Lady calling, asking him where he was going. When he told the Virgin of his uncle's condition, she said that he should not "fear this sickness, or any other sickness or anguish." She asked, "Am I not here, your Mother? Are you not under my shadow and protection? Am I not your fountain of life? Are you not in the folds of my mantle, in the crossing

of my arms? Is there anything else that you need?" How many of us in a deep place of prayer have had this experience of needing nothing but the love and grace of the Divine?

As Juan Diego accepted Guadalupe's authority, his uncle was healed, and Juan Diego "left feeling contented." Now at peace, Juan Diego asked the Virgin to give him a sign to take to the bishop. The Virgin ordered him to go to the top of Tepeyac and look for roses to cut, gather, and bring to her. Even though roses were long out of season, Juan Diego found an armful of roses for Guadalupe. She touched the flowers, making herself present in them, and counseled him to reveal them only to the bishop.

Filled with faith and resolve, Juan Diego returned to the bishop's palace. Again, despite the disrespect and ridicule of the courtiers, he held his ground and waited to see the bishop. The servants finally informed the bishop of Juan Diego's presence and allowed him to enter. He told his story once more and then presented the roses to the bishop. As the flowers fell from Juan Diego's *tilma* (cloak), the image of Guadalupe appeared in their place. When the bishop and those around him saw it, they knelt in repentant respect.

The story of Guadalupe tells of the restoration of human dignity. Ultimately, it speaks of a shared experience of a people that suffers. When everything else in the world of the Nahuatl people had been destroyed, the Guadalupe empowered and renewed the people. Embodying their identity, Guadalupe spoke in their language and was clothed in their symbols. She validated their place in the world and led them to a deeper wisdom.

Janet McKenzie's image of Guadalupe is strikingly different from any image of Guadalupe that I've known. But I understand the importance of context and the inescapable mediation of culture. When I first saw it, I sat back and asked myself, "Where does this come from?" Ahh, I realized, she's painting in New Mexico, known as La Tierra Santa.

New Mexico is the land of enchantment. It's a land of cultures and contrast, dramatic vistas carved from desert and mountains, bathed in a pure translucent light. This seems to make for vivid images, of sky and desert, mountains and forest, with bluer blues, and a richer contrast between the skies and the tawny hues of the desert and the adobe structures that dot the landscape. Huge expanses of scrub

are offset by the purple blue shadows cast by mountains and gullies. It's like being in God's great outdoor cathedral.

Various Indian tribes created the backbone of New Mexico's mysticism, and its culture today is a unique expression of Indian art mixed with Hispanic and European influences. In this particular expression of the Guadalupe, we can also see the influence of African American and even Asian sensibilities. A visitor to Santa Fe and Taos can almost feel the mystical qualities embedded in the land and breathe the ancestral air of the peoples that came before. They color your vision and stimulate artistic expression of all kinds, as well as a peace of spirit, an elevation of the soul.

While at first I may not have recognized the Guadalupe in the form I'm used to, I did recognize the Divine in creation, the intimacy and tenderness of her touch on the Juan Diegos of the world. It is this breathtaking peace, love, and tenderness that come through, and that is what matters. I see this universal and deeply human story appropriated into the understanding of yet another culture.

However portrayed, the devotion of Our Lady of Guadalupe continues to tell a universal story that makes God's presence known and suggests a deeper need to experience the maternal face of God. In our broken human condition we need to hear the promise of peace in our hearts, especially in the midst of our most desolate and darkest moments. We need to be reassured that we are not alone in the world and that there is a loving God who continually seeks us out and chooses to live among us. For those who suffer because of violence, war, poverty, marginalization, and isolation or anger, Guadalupe is faithfully present as we struggle through fear and despair. She urges us, and the smallest of her children, to guard in our hearts the certainty of her love and compassion.

Blessed Kateri Tekakwitha

Eva Solomon

he story of Blessed Kateri Tekakwitha is very similar to that of my friend Baajiiñgwetemok (Gently Rolling Thunder). Her experience, as well as my own journey, has helped me appreciate Blessed Kateri's story more profoundly.

When Baajiiñgwetemok first learned of Blessed Kateri, she was fascinated by the story, as she could easily identify with Tekakwitha's life and faith journey. Like Blessed Kateri, Baajiiñgwetemok was also orphaned as a child. After losing her mother to a terrible illness, she was adopted by her aunt and uncle who raised her according to Anishinaabe (Ojibway) traditions. Christianity had not yet come to their village, although some had heard of it; some found it acceptable while others did not. As a young girl, Baajiiñgwetemok had visions of a person dressed in white who descended from the sky and whom she called "Son of Man" (Wegozhsisimind) She was not afraid of him and somehow understood that he came in peace for the healing of her people.

Later, when Baajiiñgwetemok told her aunt and uncle that she had learned of Jesus from others and wanted to become a Catholic, her uncle was not in favor of it. Like others in his village, he believed that "the Creator gave the newcomers their way and it is okay for them, but Gitchi Manitou has given us our *own* way that is right for us." Her relatives shared their feelings about this "new way," but they also respected her choice. Her aunt told her, "If you are going to be baptized, that is also a good way of life. The only thing is, if you choose it you have to live it to the full and the best way that you can." Baajiiñgwetemok was baptized as a young adult. She realized that the one she had seen several times as a child and had called "Son of Man" was really Jesus and that he was also known as "Son of Man."

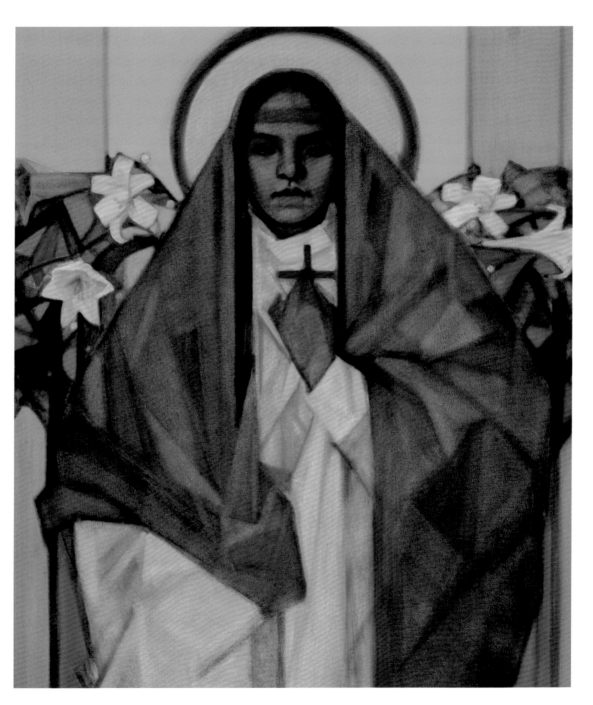

Blessed Kateri Tekakwithai, oil on canvas (30 x 30 in)

Collection of the Catholic Diocese of Salt Lake City, Utah

In turning to the story of Blessed Kateri, we need to understand how the unique experience of any society very much affects the perceptions of those who write its history. Most Aboriginal people experience no separation between the various worlds: the past, present, future, the physical, mental, emotional, and spiritual worlds were, and remain, simply different dimensions of the same reality. Europeans of the time saw things differently. They saw themselves as "cultured, enlightened, and sophisticated" and the peoples of the new world as savages who were "primitive" or "primordial." In fact, the indigenous peoples had different but not inferior world orders, political dynamics, economic systems, and social and religious structures. Their structures were holistically entwined and could not be separated or compartmentalized. They had lived on the land for thousands of years, and their knowledge of the land — all that it contained, their interrelationships, and nature's cycles of life — had sustained them for millennia. Their independent nations and confederacies had been long established.

However, the Holy Roman Empire believed in the superior right of the church over all, including earthly rulers. Papal bulls of 1493 and 1537 sanctioned Spanish and Portuguese colonization, giving the colonizers authority to conquer and subjugate the peoples, winning their souls for Jesus Christ.

By the early 1600s and prior to the arrival of the French Jesuits in Hochelaga (today's Montreal) the indigenous Mikmaq Confederacy had already established a concordat with the Vatican as an independent Catholic republic. Although Jacques Cartier had claimed the land in the name of the king of France, the French in the "new world" considered their relationship with the indigenous peoples of New France to be more of a trade alliance. However, in 1627 the king of France granted all of North America that was not already occupied by a "Christian prince" to the Company of New France. Then in 1651 he granted the Jesuits fishery and establishment rights in all lands acquired by them in both North and South America. The indigenous people could not understand how this could be possible. During that same time, the governor of the new territory granted guns to the neophyte Christians as "a powerful attraction to win them," while refusing to allow "infidels" to possess guns.

It was in this context that Tekakwitha was born in 1656 of Algonquin and Iroquois ancestry. Her mother was a Catholic Algonquin and her father a Mohawk who followed the traditional spirituality of his people. Both her parents and her

baby brother died in the 1660s from smallpox. Kateri, who survived, although weak, pock-marked, and nearly blind, was adopted by her father's brother, a Mohawk chief. Because of her limited sight she was given the name Tek-ak-with-a ("she who gropes to find her way" or "she who puts things in order").

Several hallmarks of Aboriginal peoples are their keen observation skills and their attentiveness and ability to read the signs of their environment as they constantly seek to understand the meaning of events, particularly in relationship to themselves. They are aware that their daily physical lives can be directly influenced by any aspect of their total reality. Kateri was very present to the moment, as were Jesus and Mary and even the disciples, who spent their lives trying to discover who they were, to learn from their experiences, and to understand what it all meant.

Because of her own grief at the loss of her family and her suffering from smallpox, Kateri was easily able to identify with Jesus and his sufferings even before becoming a Catholic. After his life, death, and resurrection, Jesus became transhistorical and transcultural. It was thus possible for him, in his love, to have inspired Blessed Kateri long before she became Catholic.

When Tekakwitha encountered Catholicism she was able to ask, "What does this mean for me?" as she had done all her life with events and people. It was not surprising then that when her uncle and aunts arranged for her marriage at an early age, according to traditional customs, she refused, as she was not interested in marriage.

In 1676, when she was twenty, Tekakwitha was baptized Catherine (Kateri) by Fr. Jacques de Lamberville. Fr. Claude Chauchetière described her as "gentle, patient, chaste, innocence [sic] and a child well behaved." Her traditional spirituality and values led her to care for the elderly, the sick, and the little children. This was a God-given way to be in relationship with her Creator, herself, others and all of creation. Catholicism would only enrich what God had already given her, as it did for my friend Gently Rolling Thunder.

Kateri was graced with a great love of God, Jesus, and Mary, and a mysticism and deep sense of prayer. She attended daily Mass and prayers. In seeming remembrance of Jesus' redeeming life, suffering, death, and resurrection, and her own suffering, she created a shrine in the forest where she could pray. When Kateri expressed her desire to start a religious community of Aboriginal women, she was

dissuaded by the priests as too new to the faith. They did, however, permit her to make a vow of virginity in March 1679. She was also given to much penance and fasting, which may have contributed to her poor health and even early death. Those around her considered her saintly, and as she grew weaker she promised that she would pray for her people when she got to heaven.

Kateri died on April 17, 1680, at age twenty-four, after pronouncing her last words, *Jesos Konoronkwa* (Jesus, I love you). Within minutes of her death her face became radiant and the scars of smallpox disappeared. In 1943 Rome declared her Venerable and in June 1980 Blessed. When she is finally canonized as St. Kateri Tekakwitha, she will serve as a model for all peoples of the world, and especially the indigenous.

In describing this painting, Janet McKenzie wrote,

I came to know of Blessed Kateri Tekakwitha through a friend. I listened to what he said and I read about her, but it wasn't until I traveled to her shrine in Fonda, New York, that I felt called to create an interpretation. Her presence there is palpable. Around every birch and pine tree, behind every soft breeze, while walking the cold earth — her land — you can feel her. Passionate devotion to the Lily of the Mohawks is evident in the multitude of small handwritten notes tucked all over the shrine, each asking for her intercession for a beloved.

My vision of Kateri, which repeatedly came to me after my visit to Fonda, shows her right at the moment of release from her earthly suffering and radiantly beautiful. Her head covering, which she used to protect her damaged eyes, is off her face and her ravaged skin is smooth. Flanked by lilies, she looks out at us, holds a cross to her heart as a symbol of her unshakeable faith.

Blessed Kateri has profoundly influenced my life. She was declared Venerable a few months before I was born and while I was still in the womb my mother spoke of Kateri. Kateri was very genuine for my mother, who knew other Mohawks and was herself part of the Algonquin family. Kateri directly influenced my vocation as an indigenous person and I still remember clearly sensing her presence in 1960 as I prayed to her for healing for a family member. Kateri has led me to experience God's direct call to help our people to recognize their own beauty, goodness, and dignity as individuals and as a community.

Her greatest legacy to us Aboriginal people is her sense of hope and her love of God, of Jesus our Elder Brother, and of Mary our Mother. She gives us the courage to stand with dignity before those who continue to ridicule and discriminate against us. And she shows us that we, as Aboriginal peoples, are important to our God and to the church. Like her, we too will show the face of God to others in a way that no one else can.

Blessed Kateri, Lily of the Mohawks, may you lead others, like my friend Baajiiñgwetemok, to recognize God's love and power in their lives. Thank you for your prayers for us. May you soon be canonized!

Sources

Dickason, Olive Patricia. *Canada's First Nations: A History of Founding Peoples from Earliest Times.* Don Mills: Oxford University Press, 2002, 86.

———. *The Myth of the Savage and the Beginnings of French Colonialism in the Americas.* Edmonton: University of Alberta Press, 1997.

Henderson, James (Sákéj) Youngblood. *The Mi'kmaw Concordat.* Halifax: Fernwood Publishing, 1997.

Website: www.thelifeofkatertekawitha.

The Keepers of Love
China Galland

y name is Nuthel Britton, and I am the Keeper of Love," said the tall, smartly dressed older woman across the table from me. On this balmy evening in early May of 2002 we were gathered in a church basement in Marshall, Texas, near the Louisiana border. Seated around a library table were a Catholic priest, an Episcopal priest, two African American preachers, one Baptist and one AME, as well as Mrs. Britton, Mrs. Doris Vittatoe, Gail Beil, and myself. The self-proclaimed "Keeper of Love," Mrs. Britton, turned to me with a smile so radiant that it could have brought up the sun. And this is how Love Cemetery changed my life.

I was an outsider in the community. Although I go back regularly to visit family in east Texas, where I spent much of my childhood, I live in California. On one of my visits, I had been introduced to an African American elder who asked me to help her get into the cemetery that family had been locked out of for roughly forty years. The burial ground, dating from the 1820s or 1830s, had been unmarked and untended since the 1960s. It was now a shambles of broken headstones overgrown with a tangle of aged but still blossoming and fragrant wisteria. An elderly white historian who knew of the burial ground but refused to put up a marker encouraged me to contact Mrs. Doris Vittatoe, the secretary of a nearby church, a person with the most information about black history in the area. Doris told me how many years ago some white people had cut local African Americans off from their ancestors and from their own history. She also spoke of her own mother's sadness on her deathbed as she recounted how she had never been able to get back into Love Cemetery to clean her mother's grave.

Mrs. Britton spoke again, "Love is the cemetery that my grandmother, Lizzie Sparks, is buried in, and my uncles too, her sons. We've been locked out of Love for nearly forty years. China, I want you to help me get back into it. It's the

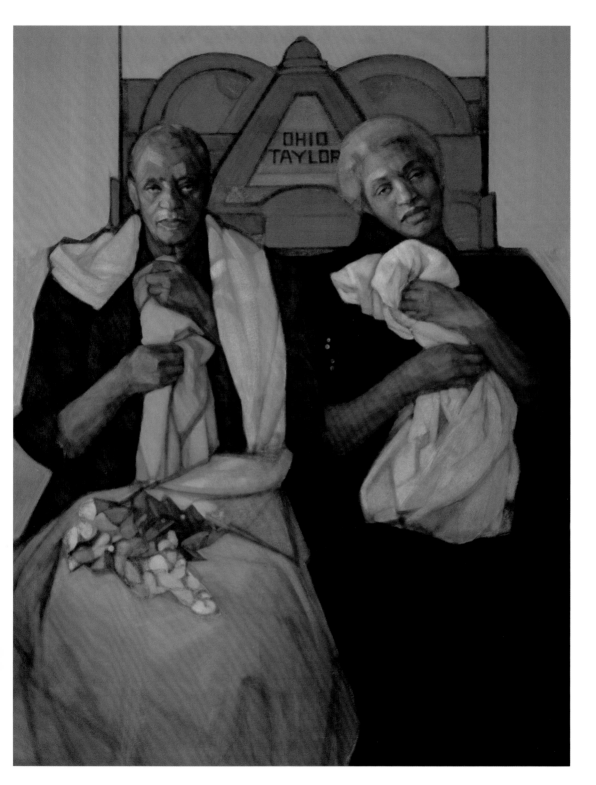

The Keepers of Love, oil on canvas (42 x 54 in)

most beautiful place in the world." Nuthel asked me to help her identify the surrounding landowners and get access restored to the community's nineteenth-century African American burial ground.

Love Cemetery is a historic 175-year-old African American cemetery that lies on ground deeded to the Love Colored Burial Association in 1904 by Della Love. There are at least thirty-nine grave markers indicating burials over the 1.6 acres. Love contains the graves of African Americans and at least one known Native American–African American, that of Mrs. Britton's grandmother, Lizzie Sparks. Several descendants still live nearby but for more than forty years they have been unable to care for their ancestors' graves.

Janet McKenzie and I had become friends and correspondents out of our shared love for Black Madonnas. Janet painted contemporary images of them while I photographed and wrote about them. At the time I was in the midst of writing *Love Cemetery: Unburying the Secret History of Slaves.* Janet was fascinated with my stories of Love Cemetery and my accounts of getting to know Mrs. Britton and Mrs. Vittatoe. When she asked me about possibly painting Mrs. Britton and Mrs. Vittatoe, I could only say yes, do ask them if they would be willing. In the midst of a howling winter snowstorm at her home in Vermont, Janet flew down to east Texas.

Janet had remembered my descriptions of the purple wisteria that grew wild and had safely hidden Love Cemetery for forty years, for she arrived with a beautiful branch of silk purple wisteria. The purple wisteria would make the cemetery present in her painting of the two women.

In *The Keepers of Love,* Nuthel Britton sits on the left and Doris Vittatoe on the right. A third person is represented by the triangular shape of the plinth behind Nuthel and Doris. This represents the headstone of Ohio Taylor (1834–1918), Doris Vittatoe's great-grandfather, a man born into slavery who died a prosperous African American farmer. His grave marker, the centerpiece of Love Cemetery, is the last vestige of the successful black farming community in which he lived.

In the painting, soft shadows fall across Nuthel and Doris as though light is coming into the room from the left. Nuthel's expression is somber, she's not letting us, the viewers, escape her presence or her direct and serious gaze. The cloth she holds supports her like a heavy walking stick and her grip on the fabric is firm.

There is an angularity in the form of Nuthel's clothes, which form diagonals across her lap and seem to be echoed in the angles and planes in her face.

Doris's expression is softer and filled with emotion. She holds the cloth in her hand close to her heart, almost as though it swaddles an infant. Their images are suffused with an overwhelming dignity and stillness.

The steady, penetrating gaze of Nuthel and the quiet, constant sorrow of Doris have grounded me and confronted me time and again with the choice all of us must make. It is a haunting call from the Ancestors to accept the sacredness of life in each moment and to acknowledge its preciousness. Janet's painting reflects that moment when the Divine suddenly erupts amid daily life and confronts us. For me *The Keepers of Love* has become a lodestone that continually challenges me to stand up and be counted, to speak out. It is a constant reminder that there are few choices in life as powerful and transformative as following our conscience.

And that lovely branch of purple wisteria in Nuthel's lap reminds me of the sacredness of the Earth in its many dimensions. On my back deck in California I grow wisteria from cuttings from Love Cemetery. They bloom along with the flowers of purple iris and salmon and gold gladiolus, offshoots of my great-grandparents' garden, glowing softly like the soft colors of the folds of cloth held by Doris and Nuthel. Each day the flowers remind me of Nuthel and Doris and Love Cemetery, and of my own ancestors, and of what they demand of me.

The controversy around Love Cemetery and the 2008 public hearings that followed exposed the facts around more than thirty-five cemetery lockouts in Texas. On May 30, 2009, the governor of Texas signed a bill that creates new enforcement powers and penalties for violating people's rights of access to these burial grounds. The 2007–2009 lockout of Love Cemetery will end when the new law goes into effect. More information on Love Cemetery is available in a documentary film and the book *Love Cemetery: Unburying the Secret History of Slaves* (San Francisco: HarperOne, 2008). See www.chinagalland.com.

Homage to 9/11

Sarah Goodrich

n September 11 we were an intact family, a family that thought it reveled in chaos. By the middle of that day, we understood viscerally what chaos really is. It leaves a mother incapable of knowing how she will reconstruct a family without its cherished oldest son. It hands a parent silence in place of a voice that telephoned home often. It left us in shock but not in privacy.

Peter's death on board the second plane to hit the World Trade Center marked the opening of a chasm. We could not revisit the past without pain, we could not tolerate the present, and we could not conceive of a future: Peter's death completely and irrevocably altered every aspect of our lives. So complete was the transformation we could not recognize who we had become.

A little more than a year later on a cold January day, a friend told us to drive north to see a display of the paintings of Janet McKenzie in a cathedral in Burlington, Vermont. We went, seeking solace and spiritual consolation. While *Homage to 9/11* called out to me in my grief, I desperately needed a respite from 9/11, not a reminder. I resisted its draw because it was simply too painful. Unknown to us at the time, we were seeing a representation, an actual depiction, of how we would eventually lay claim to and reconstruct lives that had been shattered. The image was prophetic.

Just before the third anniversary of September 11, we experienced a moment of grace as seemingly random and capricious as the moment of Peter's death. Its implications were just as profound. Major Rush Filson, a childhood friend of Peter's stationed in Afghanistan, e-mailed his parents about an Afghan teacher who had changed his view of the world, and they shared his e-mail with my husband. For us, that simple act of kindness bridged a chasm between past and present, and it

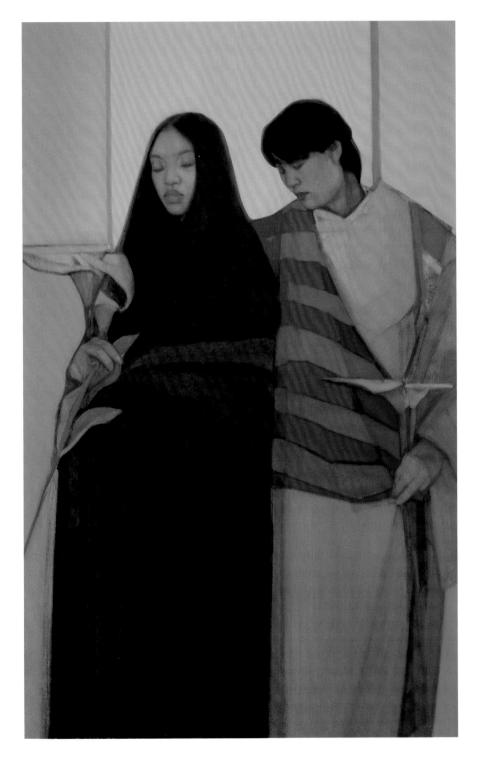

Homage to 9/11, oil on canvas (34 x 54 in)

Collection of Sally and Don Goodrich, Bennington, Vermont

began a journey that continues today. It has not been a journey of one person but of many people who believed that they could create a safer, more equitable world.

I remembered *Homage to 9/11*. It seemed then to be an icon that could convey the inexpressible part of our journey. I wondered if Janet McKenzie still had the painting and if it might be for sale. It called us to action and spoke of our yearning for a world that was qualitatively different from the one that existed on 9/11. When I asked her to describe *Homage* in her own words, this is what she wrote:

The idea of painting something — anything — in response to September 11 seemed wrong. What possible good could come of painting anything at all about this event that wounded us all, and certainly some of us more than others? I rationalized that anything I said through my art would wind up being trivial by comparison. So I made the decision not to create a painting about 9/11. Yet, art is a strange partner to live with, and expression sometimes refuses to be denied. Sometimes ideas move forward into form and then go out and into the world, regardless of a mind trying to stop them.

Homage to 9/11 was born this way — spontaneously. Two figures emerged on canvas, upright and leaning into one another. Eyes closed. I knew who they were halfway through painting: they were the Twin Towers. The two women stand together against the color of ash. They mourn, but they stand. They are mothers without their children. They simply hold flowers, the purest of offerings, reflecting hope, and symbolic of the masses of flowers left throughout New York. The women reflect our mutual suffering and profound loss, personally and as beings on this earth together. But this work is not only a recognition of mutual suffering; I feel this work is also about our inherent human goodness, our strength and purity as people together — because they stand united and in a similar spiritual place.

Homage to 9/11 became ours, and so began our work in Afghanistan. We started modestly by collecting school supplies for Rush's teacher because that is what we were asked to do. But, as Robert Frost wrote in "The Road Not Taken," "way leads on to way." Within months we had committed to building a school for girls in Afghanistan. As time passed I was asked to speak in many different places and I always took the painting with me. *Homage* allowed the viewer to contemplate

the inward spaces and emotions of our journey — something to which I could not give voice.

Although it was a risk, both emotional and physical, we were able to undertake our work in Afghanistan because Americans like Kathleen Rafiq, a humanitarian and photographer, and David Edwards, an Afghan scholar and professor of anthropology at Williams College, provided wise counsel and introduced us to the best of an ancient race of people. Thanks to Kathleen and David, Afghans Shahmahmood Miakhel and Saraj Wardak embraced us and introduced us to others. We met educators and teachers who believed in the need to educate their children about Afghanistan and the value of serving others. But most of all, we could take that journey because it was consistent with the way Peter had lived his life.

We justified our actions by using a recommendation of the 9/11 Commission as our rationale: "The United States should rebuild the scholarship, exchange, and library programs that reach out to young people and offer them knowledge and hope. Where such assistance is provided, it should be identified as coming from the citizens of the United States." We agreed that no country can create a safe and prosperous future without educated citizens.

In addition to building the school, digging a well in Kunar, constructing a library in Bamyan, and partially funding the needs of orphans in Wardak, the Peter M. Goodrich Memorial Foundation contributes to the education of twelve Afghan students here in the United States. All have different stories, but each echoes the tales of adversity I heard everywhere in Afghanistan. These young people will be part of the next generation of Afghanistan's leaders. They are the hope of their country. When we show them *Homage to 9/11,* they take comfort in a painting that affirms their place in our lives, our home, and the world. We find strength in its central message that suffering cannot extinguish "our inherent human goodness, our strength and purity as people together. We stand united and in a similar spiritual place."

I know now that suffering is the universal language that prepares us for greater insight and understanding. We have seen the rugged beauty of a country never valued for itself, and we have met noble, generous people who have helped us to understand the circumstances that laid the ground for 9/11. I have learned to understand the value of true Islam as it is practiced in the villages of the

countryside, and I have stayed with a former *mujahedin,* a member of the Taliban who is weary of conflict. He protected me as he protects the widows and orphans in his care even as security quickly deteriorates in his village. I worry that he will be targeted and that no one will be there to oversee the orphanage, health clinic and the school for girls and boys that he has developed.

The Goodrich Foundation has been the recipient of gifts large and small from those known and unknown. And the by-products of our journey, and of the gifts of others here and in Afghanistan, continue to be faith, trust, and hope.

Are our lives imitating Janet's art? It seems so to us. Time and time again we are called to her vision of the possibilities of our lives. In the photographs taken by Kathleen Rafiq, especially those of the principal of our Afghan school and myself, standing together, I see reflections of the image of the two women in *Homage.*

Our love for Peter, the only certainty following his death, sustained us as Afghan children entered our lives. As Peter's legacy of love encompassed all of us, our fears subsided. Even today, eight years later, we still struggle to understand this ancient culture. Just as the two women (are they also mothers?) stand in close proximity, seeming to look inward to ponder the failures of the past and the possibilities of the future, so do we try to bridge the complexities of living together in a troubled, complex world.

I see the flowers held by the women as a message of hope, the kind of hope that Václav Havel, the former president of the Czech Republic, described in *Disturbing the Peace:*

> The kind of hope I often think about . . . I understand above all as a state of mind, not a state of the world. Either we have hope within us or we don't; it is a dimension of the soul, and it's not essentially dependent on some particular observation of the world or estimate of the situation. It is an orientation of the spirit, an orientation of the heart; it transcends the world that is immediately experienced and is anchored somewhere beyond its horizons. . . . Hope is definitely not the same thing as optimism. It is not the conviction that something will turn out well, but the certainty that something makes sense, regardless of how it turns out. It is this hope, above all, which gives strength to live and continually try new things.

Contributors

Anita Price Baird, D.H.M., is a member of the religious congregation of the Society of the Daughters of the Heart of Mary. She is the founding director of the Office for Racial Justice of the Archdiocese of Chicago, where she oversees the archdiocese's antiracism initiatives and serves as Cardinal Francis George's liaison for race relations. She travels extensively to present antiracism workshops and is well known in the African American Catholic community for her preaching and retreat ministries. Sr. Anita lives in Oak Park, Illinois, and serves as regional superior for her order's communities in Chicago, St. Louis, and St. Paul. She loves cooking, going to the theater, and traveling, with Paris and Ghana as her favorite places.

Diana Butler Bass is an author, speaker, and independent scholar specializing in American religion and culture. She is the author of seven books, including the best-selling *Christianity for the Rest of Us,* which was named one of the best religion books of the year in 2006. Her most recent book is *A People's History of Christianity.* She is currently Senior Fellow at the Cathedral College of the Washington National Cathedral in Washington, D.C. Diana regularly consults with religious organizations, leads conferences for religious leaders, and teaches and preaches in a variety of venues. An Episcopalian, she lives with her family in Alexandria, Virginia.

Although **Sr. Wendy Beckett** has been a hermit for the past thirty-seven years, she is well known through her books and TV documentaries on art. However, her "real life" is one of prayer, which she lives out in her hermitage, a trailer behind a Carmelite monastery in Quidenham, Norfolk, England. After a mystical experience as a young child, she joined the Sisters of Notre Dame de Namur and later, after attending Oxford, taught in South Africa. In 1970 she left the order to become a consecrated virgin under the protection of the Carmelite monastery. Her two most recent books are *Sister Wendy on Prayer* and *Encounters with God: In Quest of Ancient Icons of Mary.*

Susan Calef is a member of the Department of Theology at Creighton University, where she teaches graduate and undergraduate courses in New Testament, directs the Women's

and Gender Studies Program, and teaches "Scriptural Foundations of Spirituality" in the Christian Spirituality Program. Much of Susan's research and writing offers a feminist reading of canonical and extracanonical texts that depict women or bear upon the lives of women. As a New Testament scholar interested in the biblical roots of Christian spirituality, Susan has been exploring the narrative theology and spirituality of the canonical gospels in order to identify the transformative potential of each. In addition to her work at Creighton, Susan speaks to church and women's groups on biblical topics and gives Scripture-based retreats.

Katie Geneva Cannon is the Annie Scales Rogers Professor of Christian Ethics at Union-PSCE in Richmond, Virginia, one of ten theological institutions of the Presbyterian Church (USA). A native of Kannapolis, North Carolina, Cannon is the first African American woman ordained in the United Presbyterian Church (USA) in 1974, and the first African American woman to earn a Ph.D. from Union Theological Seminary in New York City. Dr. Cannon is the author or editor of six books including *Teaching Preaching: Isaac R. Clark and Black Sacred Rhetoric, Katie's Canon: Womanism and the Soul of the Black Community*; and *Black Womanist Ethics*. She is currently working on a new manuscript, "The Pounding of Soundless Heartbeats: A Womanist Mapping of the Transatlantic Slave Trade."

Joanna Chan, M.M., has been a playwright and stage director in North America, Hong Kong, Taiwan, and China for nearly four decades, having written, adapted, and directed nearly sixty stage productions. She has served as co-founder and artistic director of the Four Seas Players in New York City, as artistic director of the Hong Kong Repertory Theatre in the 1980s, and as the co-founder and current artistic director of the Yangtze Repertory Theatre of America in New York. Her 1988 drama, *Crown Ourselves with Roses,* was selected as one of the most significant works in Chinese theater in the past hundred years and will be included in *An Anthology of Modern Chinese Drama* to be published by Columbia University Press in 2009. An accomplished painter and designer, Chan is also a Maryknoll Sister.

Joan Chittister, O.S.B., was a Janet McKenzie fan long before contributing to this book. Her Benedictine community in Erie, Pennsylvania, displays Janet's *Epiphany* in its chapel entranceway each January on the feast of the Epiphany itself. During the rest of the year it hangs in Sister Joan's Benetvision office. Benetvision, a research and resource center, was started by Joan in 1990. Its website (benetvision.org) lists all of her publications, including books, booklets, prayer cards, and CDs. A weekly online newsletter updates her many followers on her latest speaking engagements, upcoming publications, and weekly columns. Joan's latest book is *The Gift of Years: Growing Older Gracefully.*

(Chung) Hyun Kyung is an associate professor of theology at Union Theological Seminary in New York City. She defines herself as a "salimist" (Korean ecofeminist) from the Korean word *salim*, which means "making things alive." She works to synthesize the wisdom of the worldwide peoples' movements, the spiritual legacies of Asian religious traditions, critical academic analysis, and the world of the arts in her theology. She has also produced an award-winning, eight-part series, "The Power of Women in World Religions," for Korean public television. She is the author of several books in Korean as well as *Struggle to Be the Sun Again: Introducing Asian Women's Theology* and, with Alice Walker, *Hyun Kyung and Alice's Fabulous Love Affair with God.* After twenty years of studying and practicing, Hyun Kyung has also become a Buddhist Dharma teacher in the Korean Zen tradition.

M. Shawn Copeland is a theologian and writer whose aesthetic interests range from the music of J. S. Bach to Mary Lou Williams, from the tragicomic paintings of Robert Colescott to the politically charged prints of Elizabeth Catlett, from precolonial West African sculpture to the public installations of John Scott, from the poetry of Wislawa Szymborska to the novels of Toni Morrison. Her theological work is motivated by a desire to unmask the social oppression and suffering of the poor and excluded. She is the author of *The Subversive Power of Love: The Vision of Henriette Delille*; *Enfleshing Freedom: Body, Race, and Being*; and editor of *Uncommon Faithfulness: The Black Catholic Experience.* She teaches at Boston College and lives in Watertown, Massachusetts.

Sally Cunneen is the co-founder and a longtime editor of *CrossCurrents*, an international, interreligious quarterly. She is Professor Emerita of English at Rockland Community College, SUNY, where she taught literature and writing for twenty-two years. She has published numerous articles on literature and on women and religion, and she is the author of five books, most recently *The Rebirth of the Icon*, with artist Frederik Franck. Her best known book is *In Search of Mary: The Woman and the Symbol.* It was in researching this book that she became deeply interested in the way that images can convey meaning often beyond words.

Paula D'Arcy is an author, speaker, and playwright. Her nine books include *Gift of the Red Bird* and *Sacred Threshold.* A former psychotherapist, Paula leads retreats and seminars worldwide and is a frequent teacher and seminar leader at the Oblate School of Theology in San Antonio, Texas. She also lends leadership to her nonprofit Red Bird Foundation, which sponsored WOMENSPEAK in 2007, an international gathering of women to create a voice for world peace. Paula is deeply involved with Arab and Jewish women in Israel and their efforts to create healing bonds and to foster peace. Her own healing journey

began in 1975 with the sudden death of her husband and daughter in a drunken-driving accident. Pregnant at the time, Paula now lives in Texas, as does her surviving daughter.

Born and raised in Texas, **China Galland** is the award-winning author of *Love Cemetery: Unburying the Secret History of Slaves.* A new edition of her earlier work, *Longing for Darkness: Tara and the Black Madonna,* was issued simultaneously with *Love Cemetery.* China is one of the world's foremost authorities on these powerful, positive, dark female images of the Divine. She is a professor in residence at the Center for the Arts, Religion, and Education (CARE) at the Graduate Theological Union in Berkeley, California, and teaches and lectures nationally and internationally on race, religion, reconciliation, the arts, and the environment. Her nonprofit work, "The Keepers of Love," is sponsored by CARE. She is the 2009 recipient of "The Courage of Conscience Award" from the Peace Abbey in Sherborn, Massachusetts.

Edwina Gateley is a speaker, writer, poet, and women's advocate. She is author of thirteen books and the recipient of fifteen national and international awards for her work for justice and for women — especially those caught up in a lifestyle of prostitution. Edwina believes that women's work and wisdom have long been ignored or marginalized by both society and church — particularly the call to motherhood. Her most significant and hard-won award is "Mom of a Teen in the 21st Century" (self-awarded).

Sarah (Sally) Goodrich, an educator and a reading specialist, lives in Bennington, Vermont, with her husband, Don. Their oldest son, Peter, a passenger on United #175, was killed when the plane was flown into the South Tower of the World Trade Center on September 11, 2001. Shortly after, Sally and Don established the Peter M. Goodrich Memorial Foundation (www.goodrichfoundation.org). It has built and supports a school for 520 girls in rural Afghanistan. In addition to financing water projects and other educational projects, it supports the education of eleven young Afghans in this country and three in Afghanistan. Sally and Don have two surviving children and five grandchildren. Sally, who has been to Afghanistan six times, has come to know and deeply admire the people of that country.

The Rev. Canon Mary E. Haddad, from Windsor, Ontario, began her professional life in television with the Canadian Broadcasting Corporation. She has also owned and run a French café and sold Toyotas in Detroit. After serving as the on-site verger at All Saints' Church in Beverly Hills, she entered the seminary and then joined the staff of St. Bartholomew's Church in Manhattan as a teacher and preacher engaged in a creative ministry of justice and interfaith understanding. In 2007, she moved to San Francisco to

become the canon pastor at Grace Cathedral. Passionate about the intersections between faith and culture, Mary emphasizes "Practicing Jesus" — connecting sacramental worship and theology to the habits and practices of daily life.

Diana L. Hayes is a professor of systematic theology at Georgetown University. The first African American woman to earn a pontifical doctorate in Sacred Theology at the Catholic University of Louvain in Belgium, she also has a law degree. She is the author of six books and over sixty articles in journals and edited books. At this time, Dr. Hayes is completing work on a new book for Orbis, *Forged in the Fiery Furnace: African American Spirituality.* Her areas of interest include black and womanist theologies; contextual theologies; the intersection of race, class, and gender with religion; religion and culture; religion and public life; African and African American religions; and spirituality and comparative religions. She has lectured widely in the United States, Africa, and Europe.

Katharine Jefferts Schori became the twenty-sixth presiding bishop and primate of the American Episcopal Church in 2006. Bishop Jefferts Schori holds a Ph.D. in oceanography from Oregon State University and worked as an oceanographer before studying for the priesthood at the Church Divinity School of the Pacific. She previously served as bishop of the Nevada diocese. As presiding bishop, she serves as chief pastor to the Episcopal Church's 2.4 million members in 110 dioceses and joins in consultation with the other principal bishops of the worldwide Anglican Communion, seeking to make common cause for global good and reconciliation.

Elizabeth A. Johnson, C.S.J., is Distinguished Professor of Theology at Fordham University in New York City. Her many books, translated into multiple European and Asian languages, include *She Who Is: The Mystery of God in Feminist Theological Discourse* and most recently, *Quest for the Living God: Mapping Frontiers in Theology of God.* Recipient of honorary degrees and awards, she has found receiving the annual teaching award at Fordham the most gratifying. A former president of the Catholic Theological Society of America and of the interreligious American Theological Society, she has lectured widely in the United States and abroad. When not theologizing, she enjoys gardening, photography, music, and reading mystery novels.

Mary Jo Leddy is a Canadian writer, speaker, theologian, and social activist. For the past eighteen years she has been living with refugees at the Romero House Community in Toronto. It is here that she has been summoned to become more Christian by uprooted people from various parts of the world. She has traveled extensively for human rights, peace, and religious concerns, visiting Italy, Spain, Lebanon, Israel, Egypt, the former

Soviet Union, El Salvador, and Costa Rica. A frequent radio and TV commentator, she also teaches theology at the University of Toronto and is the author of several books, including the bestselling *Radical Gratitude.*

Barbara Lundblad, the Joe R. Engle Professor of Preaching at Union Theological Seminary in New York City, is an ordained minister of the Evangelical Lutheran Church in America who has served as both a parish pastor and a campus pastor in New York City. She preaches and leads worship regularly at her home church, Advent Lutheran Church, and has preached and lectured at many different churches and educational centers throughout the United States and Canada. She has also preached for the radio and television program *Day 1.* Her teaching interests include preaching in partnership with the congregation, preaching and social transformation, new forms of preaching, and preaching as an integral part of worship. She is the author of two books, *Transforming the Stone: Preaching through Resistance to Change* and, most recently, *Marking Time: Preaching Biblical Stories in Present Tense.*

Before retiring, **Barbara Marian** served parishes and dioceses around the country as an instructor and mentor for lay ministers. She joins other women and men working for the recognition and protection of human, civil, and ecclesial rights of those denied them. Barbara loves the theater and playing bridge, and she "skates with abandon" on her new LandRoller inlines. She also follows current biblical scholarship with great interest. Barbara commissioned McKenzie's *Epiphany, Mary with the Midwives* and the triptych entitled *The Succession of Mary Magdalene* (www.thenativityproject.com). She lives in Harvard, Illinois.

Janet McKenzie (www.janetmckenzie.com) created *Jesus of the People*, winner of the *National Catholic Reporter's* global competition for a contemporary interpretation of Jesus. After the painting was revealed for the first time on the *Today Show*, the artist faced vitriolic hate as well as worldwide celebration for her dark vision, modeled by a woman. Firmly believing everyone is created equally and beautifully in God's likeness, she has committed her life's work to advocating for women and challenging racism through her art, both sacred and secular. Her art is in many collections, including that of Cardinal Francis George of Chicago, and it has been exhibited in many venues, including the Pope John Paul II Cultural Center in Washington, D.C., and Clinique Sainte Thérèse in Luxembourg. The *New York Times*, the *London Times*, and the *Washington Post* have all written about her art, which has also appeared on the covers of many magazines. Janet, who has one son, Simeon, was raised in and around New York City by strong Scandinavian women and now lives in Vermont.

Ann Patchett is a novelist whose books have all won awards. Her first novel, *The Patron Saint of Liars,* was named a New York Times Notable Book for 1992. Her second novel, *Taft,* received the Janet Heidinger Kafka Prize for the best work of fiction in 1994, and her third novel, *The Magician's Assistant,* was short-listed for England's Orange Prize and earned her a Guggenheim Fellowship. *Bel Canto,* won both the PEN/Faulkner Award and the Orange Prize in 2002 and was a finalist for the National Book Critics Circle Award. It sold over a million copies in the United States and has been translated into thirty languages. Her two most recent books are *What Now?* an autobiographical essay, and *Run: A Novel.* Ann lives in Nashville, Tennessee, with her husband, Karl VanDevender.

Susan Perry is a senior editor at Orbis Books, the publishing arm of the Maryknoll Fathers & Brothers, located in Ossining, New York.

Helen Prejean, S.C.J., a native of Louisiana and a member of the Sisters of St. Joseph, is known internationally for her tireless work against the death penalty. She has now accompanied six human beings to execution while providing a ministry of comfort for the victims' families. Her journey to death row, begun when she was asked to correspond with a death row inmate, resulted in *Dead Man Walking: An Eyewitness Account of the Death Penalty in the United States* (1993), her first book, which led to an Oscar-winning movie and an opera. Today Sister Helen continues her campaign against the death penalty by counseling individual death-row prisoners. This work is described in her second book, *The Death of Innocents: An Eyewitness Account of Wrongful Executions.* Helen is now writing *River of Fire: A Spiritual Journey,* an autobiographical account of her journey to be published in 2011.

Jeanette Rodriguez is a U.S. Hispanic/Latina professor of theology and chair of the Department of Theology and Religious Studies at Seattle University. She is the author of *Our Lady of Guadalupe: Faith and Empowerment among Mexican American Women* and co-author of *Stories We Live: Cultural Memory: Resistance, Faith and Identity.* She has written many articles on U.S. Hispanic theology, spirituality, and cultural memory. She also co-edited *A Reader in Latina Feminist Theology* with María Pilar Aquino and Daisy Machado. She directs her personal and professional commitments to peace-building and justice, seeking to understand and articulate the insights of the faith experience of U.S. Latinos/as. A licensed clinician dealing with family systems and a diversity trainer, she also serves as vice-chair of the National Board of Pax Christi.

Joyce Rupp is a Servite sister who describes herself as a "spiritual mid-wife," one who assists others in birthing an ever fuller and deeper faith life. She is the author of numerous

best-selling books. Besides writing, her ministry includes speaking at national and international retreats and conferences, spiritual direction, and co-directing the Institute of Compassionate Presence. She is also a volunteer for Hospice. To learn more about Joyce and her publications, see www.joycerupp.com.

Eva Solomon, C.S.J., is an Ojibway (Anishinaabe) member of the First Nations of Canada and a recognized leader in the Anishinaabe spiritual tradition. A member of the Sisters of St. Joseph in Sault Ste. Marie, she holds a doctorate in ministry from the Catholic Theological Union in Chicago. She initiated and developed the Pious Association and the Companies of Kateri Tekakwitha, named for the first Native American proposed for canonization and committed to the inculturation of faith. With Villagers Productions, she created a thirteen-part series on the Kateri movement, which aired nationally on Vision TV as well as in the eastern United States. Sr. Solomon also hosted some sixty episodes of *Distant Voices* on TVOntario. She continues to be a popular lecturer on spirituality.

Judith H. Wellington belongs to the Akimel O'odham (Pima) and Dakota tribes and is an ordained minister in the Presbyterian Church (USA). Over the last two decades her spiritual path has led her back to the traditional ceremonies of her mother's people, the Dakota. She has worked to be a spiritual companion with American Indian people, encouraging them to use the spiritual gifts that have always been available to indigenous people. Although she has a deep respect and appreciation for the spiritual practices of the Christian faith, she has found that praying with Indian people in ceremony touches their spirits in holistic ways that Euro-American liturgy and prayer cannot. Judith's interests are in promoting interfaith dialogue and cross-cultural understanding.